Jean Paul GAULTIER

CATWALK

Jean Paul GAULTIER

CATWALK

The Complete Collections

Foreword by Loïc Prigent

Texts by Laird Borrelli-Persson

With over 1,300 illustrations

Yale University Press

Contents

The Collections

Foreword

On 22 January 2020, Jean Paul Gaultier's final haute couture show was an explosion that resonated throughout the fashion world. I remember the stunned faces of the guests. It was a real show, in the true sense of the word. Hundreds of looks went down the runway, all of them worn by arbiters of cool or by icons in their own right, such as the model, muse and musician Amanda Lear and the singer Mylène Farmer.

I was supposed to be filming a documentary on his creative process, but I quickly realized that the house was close to boiling point and I was going to burn my fingers. I soon abandoned filming in the ateliers; Jean Paul Gaultier was still playing around with the styling… the place was fizzing. So I concentrated on filming the show, and what a wild ride it was.

Jean Paul Gaultier epitomizes the idea that everything is there to be challenged: established genders and genres, fashion hierarchies, what is considered beautiful, the body types that appear on the catwalk. And he interrogated his own fashion too, torpedoing his archives on the eve of his last show. For instance, he took two haute couture dresses, which any other fashion house would already have given to a museum, and cut them up to make a new outfit, a mix of the two. He held onto the same DIY spirit as that of his first ever collection, except that he was no longer working with salvaged placemats but with the most opulent fabrics and materials. Gaultier looks at an item of clothing and absolutely refuses to see it set in stone; he sees possibilities, how to unmake it and remake it, his eye working as fast as his brain – it's almost impossible to follow. He's an erupting volcano.

Over the years, Gaultier constructed a creative bubble – a studio and ateliers, together in the same building – which responded to the designer's ideas, working to the rhythms of the fashion show calendar as well as on collaborations in the fields of cinema and dance. It was an empire that pulsed solely to the beat of Gaultier's brain. No marketing, no half measures. The focus was on pleasure. Invitations to his shows were like invitations to evenings at Le Palace nightclub. His platinum hair was an expression of a guy who just wanted to dance and have fun.

At the end of the finale show, Jean Paul Gaultier was spontaneously borne aloft in triumph by his models and his team. The euphoria rivalled that of a World Cup match. I had to sleep for three whole days afterwards. It's not easy to recover from Jean Paul Gaultier.

Loïc Prigent

Introduction

And God Created... Gaultier?

In his own way, Jean Paul Gaultier has become as associated with France, and sexuality, as the blonde bombshell Brigitte Bardot. Yet his is an alternative universe, in which attraction and identity are seen with a queer eye and from an outsider's perspective. The doe-eyed ingénue is an exemplar of heteronormative attractiveness, in which women are placed on a pedestal; Gaultier's understanding of gender is more fluid and more egalitarian. Bardot is eternally associated with a teeny-weeny gingham bikini: topping a long list of Gaultierisms are striped *marinières*, trench coats, corsets and skirts for men. All of which – and so much more – you'll discover as you look through the designer's ready-to-wear and couture collections from 1976 to 2020.

If you had asked me, before I started writing this book, to share the first things that came to mind at the mention of the name Gaultier, my list would have included the designer's 1990 Pierre et Gilles portrait, complete with Eiffel Tower and daisies – an indelible and nuanced post-modern image informed by Rainer Werner Fassbinder's homoerotic film *Querelle* (1982).

Specific collections, looks and muses would, of course, be right up there: Julia Schönberg in marabou-trimmed denim (see p. 289, left), the 'Tattoos' collection (p. 198), Madonna closing a show pushing a baby carriage (p. 215), Tanel Bedrossiantz in 18th-century-inspired dress (p. 264), Chrystèle Saint Louis Augustin with a beaded ship in her hair (p. 263, left) and a tight-laced Suzanne Von Aichinger (p. 360), plus editors coming back from Paris with the most beautifully tailored Gaultier blazers. I would have talked to you about how the designer seems to have done everything first, about how his vision was inclusive and broad. And it is impossible to speak of Gaultier without recognizing his sunniness, his sense of humour, and his penchant for high camp.

Ask me now, after poring over thousands of images and hundreds of newspaper articles, and I'd add quite a few things. Added to my visual memory is an image of Anna Pawlowski, the designer's early muse, sporting a tutu and motorcycle jacket, like some latter-day Degas, in Gaultier's debut collection (see p. 26), held in a planetarium (a portent of his future stardom?). That look feels so important because it sets up many of the dichotomies that would become codified over the years. There is tailoring and flou (the traditional binary by which couture houses are organized); street/salon; punk/pretty; past/present; and androgyny.

The collision of such opposing forces resulted in aesthetic fireworks. Just as interesting is the way Gaultier worked behind the scenes, flattening hierarchies and challenging the way things had always been done. An early champion of ready-to-wear, he had a trickle-up way of working. Not only did he bring trends that started on the streets (and in the clubs) to the runway, he also started with prêt-à-porter and then went into couture, reversing the usual course. Looking through the collections you can readily observe the fluid transfer of ideas and techniques between the two types of fashion. The collection notes shared with me by the house gave testament to how designs and materials were altered, and reused, long before the designer described his final Spring/Summer 2020 collection as the 'first upcycling haute couture collection'. Think of it as the post-modern mix applied to materials and objects rather than aesthetics, references and ideas.

Gaultier's runway antics are legion – he once gave interviews at a show from a magician's box in which only his head appeared – and it has often been assumed that his m.o. was to *épater les bourgeois*. There's an element of this, of course, but as we'll discuss further on, what really drives the designer is a wholesale rejection of bourgeois values. In practice, Gaultier's 'free to be you and me' beliefs truly embody the age-old, and noble, French ideals of *liberté, égalité, fraternité*.

Jean Paul Gaultier was born on 24 April 1952 in the suburb of Arcueil, located about 20 kilometres away from the Eiffel Tower (which would become one of the designer's favourite motifs). As the only son of an accountant and a clerk, Gaultier's origins are lower-middle-class, in a culture in which status matters. Yet the designers in history he is most akin to are the cosseted, Proust-loving Yves Saint Laurent and the aristocratic Elsa Schiaparelli.

Not only was the young Frenchman at a physical remove from Paris, but his homosexuality and a feeling of otherness (which sometimes converged) contributed to a sense of difference, which he would turn into his superpower. When it came time to establish his own *maison de couture*, Gaultier maintained, by choice, a geographical separation from luxury's 'Golden Triangle'; his first boutique opened in the Galerie Vivienne covered arcade in 1986, and later he situated his headquarters in the 'Proletariat Palace', a former worker's club (among other things), at 325 rue Saint-Martin.

The designer started visiting London in the 1970s, and Franglais was his preferred tongue, especially at the start of his career. He felt a sense of solidarity with the punks, adopting the motto 'too fast to live, too young to die', and later with the New Romantics. 'I love the eccentricity and the freedom [of London],' the designer has said. 'Whereas in France we are a little bourgeois: there's no

sense of humour, no sense of self-criticism. You have always to be so nice and so elegant. Truly, I hate that, and I love that in England there is a contrast: fantasy is completely accepted.' And DIY was a default practice – one that Gaultier adopted, most obviously in the early years, showing jewelry made of tin cans and tea infusers, and garments of rattan place mats, in the best punk tradition.

From 1993 to 1996, the designer's cross-cultural diplomacy expanded to include a co-presenter role, with Antoine de Caunes, on the British TV series *Eurotrash*. By the time he appeared on the show, Gaultier was a household name – having been launched into the stratosphere by his collaboration with Madonna for her 1990 *Blond Ambition* tour. He had also settled into his public persona and a signature look. In 1989, he had released his own dance single: titled 'How To Do That', in which 'that' is pronounced like 'zat', it played on his purposely exaggerated accent. By now he wore his blond hair shaved short, had three silver hoops piercing his right earlobe, and was usually to be seen in a plaid kilt – a look he had introduced as early as Autumn/Winter 1980–81 and made as iconic a Gaultierism as the *Querelle*-inspired striped *marinière* shirts that were the centrepiece of his 1983 'L'Homme Objet' collection. With the kilt, Gaultier often wore a second-skin 'tattoo' shirt, and accessorized with biker boots of the sort drawn by Tom of Finland. In effect, he 'outed' – and normalized – elements of what had been a coded gay uniform, not only on the runway but also through his personal style.

The designer did something similar with shape and support garments, taking lingerie out from under to stand on its own; exposing what lies beneath – or what seems to. (Gaultier loves a visual gag, and his anatomical trompe-l'oeil prints are by now signature.) One of his great accomplishments is this kind of inversion, this upending, topsy-turvy approach, which forces people to face their biases and challenge their assumptions. And he puts this into practice on ideological and material levels using his technical skills: inside-out construction is one example.

It's been said that what Yves Saint Laurent accomplished through design in terms of women's liberation, Gaultier did for men. Putting them in skirts – which was shocking at the time – was not at all an attempt to feminize the 'stronger sex', but rather to put them on a pedestal, Bardot-style, in a way that benefitted *everyone*. In theory, Gaultier was always moving in the direction of true gender egalitarianism. 'My clothes are not about androgyny, not about uni-sex; they are about sexual equality,' he told *The Observer* in 1984. 'Men can be glamorous, they can be fragile and beautiful too. They have to be sexy and seductive today. Women are waiting for that.'

Unity and difference – or perhaps unity in difference, given the existence of Gaultier's semi-autobiographical revue *Fashion Freak Show* – are subject(s) the designer is always grappling with. Another preoccupation is the construction of the self through the transformation of the body – be that through makeup application, posture and gesture, body modification, or decoration. There's an underlying sense that you build a look like you would a time-travelling travel itinerary, pulling a bit from here, there and everywhere – with the meaning being in the individual amalgamate. Much as the designer advocated for equity in gender relations, so he did for a 'melting pot' view of culture. 'I take into consideration today's life. Today, people have a need to be more individualistic,' he told *Newsday* in 1984. 'Also, I travel a lot and I think that now everybody travels a lot, so there is a mixture of cultures and some culture shock. That is what's interesting now... Culturally, the world is getting much smaller, so it's more important to be flexible.'

Fashion writer Liana Satenstein has dubbed Gaultier 'the original cultural appreciator'. Critics of the 1993 'Chic Rabbis' collection, for example, might use the word 'appropriator' instead. 'I'm not sure you could do something like that today,' Gaultier stated in a 2023 interview, in which he also said: 'I really think it's always about someone else, about seeing someone who's inspiring and completely of a moment. I think that's how we're made: we see something, and then we re-offer what we've seen.' The thing is that Gaultier was looking in places and elevating people and traditions that other people weren't.

Gaultier's global vision was in sync with an MTV world in a way that was unusual. For him, a Parisienne could be a Birkin-carrying denizen of the Right Bank, or a woman from the *banlieue*; a cyber nun, or a latter-day cancan-dancing Jane Avril. In rejecting standardized ideals, Gaultier was championing different kinds of beauty in terms of ethnicity, size, age, ability, sexual orientation and body modification. You would not find such references, or casting, anywhere else in Paris.

Gaultier is responsible for many firsts – firsts that we take for granted, such as street casting. 'We're all little children of Jean Paul Gaultier,' designer Nicolas Ghesquière (who got his start with Gaultier as an 18-year-old paid intern) has said. Speaking with *The New York Times*, he described Gaultier as 'a "master of everything"', who 'broke boundaries we're now all able to explore'.

The designer's many and varied experiences have placed him in a stratosphere that exists beyond hyphenates, which, by the way, haven't stopped accumulating with the designer's retirement (from the runway only) in 2020. Although there are almost innumerable ways to describe and refer to Gaultier, one moniker has defied time

and stuck like a tattoo: the designer will forever be known as fashion's *enfant terrible*.

Among the definitions the Merriam-Webster dictionary gives for the appellation are: 1) 'a person known for shocking remarks or outrageous behavior'; and 2) 'a usually young and successful person who is strikingly unorthodox, innovative, or avant-garde'. It is true that Gaultier flew by the seat of his pants at the start; but that was as much out of necessity (his budget was near to zero) as inclination. How did the designer develop such a proclivity?

Well, before he became the archetypal post-modern designer, Gaultier was a post-war baby. The armistice ending the Second World War was signed in 1945, but Paris in 1952 was far from dazzling. Lyla Blake Ward, an American who arrived in the capital about a month before Gaultier was born, gave this account:

> *Expecting beauty and light in a city with echoes of Victor Hugo, Degas and Maurice Chevalier, we got somber darkness and bone chilling weather. We drove through grim streets, rundown houses on either side... Notwithstanding the gloomy weather, it was heartbreakingly apparent France had still not gotten her act together. In 1952, six and a half years after the end of World War II, the grime of war coated even the most beautiful buildings, causing them to appear proud but worn. The Louvre, Notre Dame and Sacré Coeur were like elderly actors who hadn't worked for a long time.*

This isn't something that the designer has spoken much about, but certainly his parents and grandparents lived through the war and severe rationing, and it's not a stretch to think that the 'make do and mend' philosophy Gaultier adopted at the start of his career was an extension of an ethos Parisians had to follow.

Adversity breeds the need for escapism. As a child, Gaultier had several sources of entertainment. There was Nana, his famous teddy bear, who was subjected to all sorts of modish experiments, but no one had more influence on the young Jean Paul than his maternal grandmother, Marie Garrabé. In addition to the corset she wore, which influenced some of Gaultier's most memorable designs, Madame Garrabé wore many proverbial hats, offering beauty treatments and ersatz therapy at her home. It was *chez* Garrabe that Gaultier observed how dress can be transformative – and not only of the body, mood, mind and mien.

At *grand-mère*'s home, Gaultier also had access to a world beyond the ordinary via television. That magic box allowed him to watch fashion reportage, the Folies Bergère (references to which are

frequent in the designer's work) and many movies. None was
more impactful than *Falbalas* (Paris Frills), made in 1945. 'Seeing
Jacques Becker's film … was a turning point for me, as I realized that
I wanted to be a couturier. Watching the fashion show at the end of
the film, I just knew that presenting shows was what I wanted to do.
That is why my fashion shows were always a bit cinematic,' Gaultier
told *Vogue* in 2024.

In the film, which features a lifelike mannequin, boundaries between
fantasy and reality are blurred. What you see isn't always what
you get in Gaultier's world either, and not only when he leans into
trompe-l'oeil effects. He once created a light-up Pigalle-themed
dress (see p. 312), and many of his designs were transformative:
a pouch might turn into a skirt, the front and the back of an outfit
might be different, and the same design could be sent down the
runway on models of different genders. The performative aspect of
dressing and of creating a persona are key to the designer's oeuvre
for runway, stage and screen. Gaultier costumed a number of films,
among them Peter Greenaway's *The Cook, The Thief, His Wife and
Her Lover* (1989), Pedro Almodóvar's *Kika* (1993) and Luc Besson's
The Fifth Element (1997).

But we are jumping ahead. Gaultier started making fashion
sketches as a boy, and his entry into fashion was quite traditional.
Like Christian Dior and so many before him, Gaultier submitted
the drawings he made as proposals to the *maisons de couture*.
As the story goes, in 1970, on his 18th birthday, Gaultier was
hired as an assistant by Pierre Cardin. While, in her *New Yorker*
profile, Susan Orlean suggests that it was Gaultier's stint at
the more traditional house of Patou that hewed most closely to
his *Falbalas* dreams, on paper the pairing with Cardin reads like
kismet. 'At Cardin everything was possible,' Gaultier has said.
'The atmosphere was very open, very free. He … did not have the
concept of an old couture house, the old concept that you cannot
do this, you cannot do that. You could do whatever you wanted.'
The same words could be applied to Gaultier himself.

Gaultier shares in common with Cardin a penchant for futurism
and unisex dressing. Arguably their most important commonality is
a belief in ready-to-wear. In 1959, the Italo-French Cardin (who had
worked on Christian Dior's 1947 'New Look' collection) was expelled
from the Chambre Syndicale de la Haute Couture for producing
a prêt-à-porter collection. It was a time of transition, marked by
the age of travel and the dawning of the Youthquake, which would
usher in a new, faster-paced and more casual lifestyle that was less
compatible with the timely, in-person fittings that couture requires.
The organization's resistance against this new category of dress
was longstanding; it was only in 1973 that the Chambre Syndicale
recognized prêt-à-porter, just three years prior to Gaultier's debut.

The designer had spent the previous year (1974–75) working for Cardin in the Philippines. Put on a 'no leave' list, he managed to get back to France by fibbing and saying his grandmother was dying. Back home he was encouraged by Francis Menuge, his life and business partner, to give it a go on his own. So, with the help of family and friends, Gaultier presented 'Biker of the Opera'. The collection, which featured the punk ballerina look mentioned above, and a long, tri-partite silhouette (small top, with skirt suspended from hips, so that a slash of skin was visible above the top of the skirt), was DIY and distinctly *not* couture. Yet in Gaultier's worldview, the glass is always half full: this wasn't so much a rejection of high fashion as an embrace of a new way of thinking from an up-and-comer of the post-war generation.

Over time, Gaultier became an outsider-insider – a status linked to his decision to take on the couture (debuting with the Spring/Summer 1997 couture season), fulfilling one of his and Menuge's dreams. Later, following in the footsteps of his one-time assistant, Martin Margiela, Gaultier would become a creative director at Hermès (2003–10), whose accessories are the utmost expression of French savoir-faire. For all his rebelliousness, Gaultier, a largely self-taught designer, has a deep respect for the *métier*. I hope you'll take as much delight as I did in observing the superb quality of his work, and the way the excellence of his technique is used to create a contemporary vocabulary.

The brand's ready-to-wear operations shuttered in 2015, after which Gaultier concentrated on couture, presenting his final blow-out collection for Spring/Summer 2020. This marked his retirement from making collections, but not from work. Executing an idea he had almost 40 years earlier when he was at Patou, Gaultier initiated a guest couturier programme – meaning that each season he invites a designer to create a couture collection based on the Gaultier archive. This has been a fantastic success, and one that keeps the house always in the news.

Concurrently a whole new generation of fashion lovers has discovered Gaultier's work, creating a demand for vintage, reissues and reinterpretations. Yet worldly status has never been Gaultier's driver. Was it a coincidence that he started in 1976, the year that America celebrated her independence? Though he was never a hippie, freedom is this designer's grail. As Gaultier said: '[I]t is not that I want to be the first one or to be the best one, it is only that I want to make what I like.' This book nonetheless shows that he achieved the whole trinity.

Jean Paul Gaultier

A Short Biography

Jean Paul Gaultier is a French designer whose wellspring of inspiration seems to flow eternal. One of the most influential creatives of the 21st century, he has an archive so vast it often seems like there's nothing he hasn't done. His proclivity for street casting highlighted his inclusive vision, and his street-influenced designs marked the change to a trickle-up approach to ready-to-wear fashion that was more suited to fast-paced times and a younger cohort.

The quintessential postmodernist, who is galvanized by the clash of opposites (high/low; street/salon; tailoring/flou), gender fluidity, and melting-pot culture in terms of size, ethnicity, sexual orientation and nationality, Gaultier is also a representative of a post-war European culture. He was born in 1952, in a suburb of Paris, when the city had not yet recovered from the war. He was 16 when students rioted in Paris in '68. Already his focus was on fashion, which he was exposed to through his maternal grandmother, and the access he had to television and film at her home.

Having submitted his sketches to the *maisons de couture*, at 18 Gaultier was engaged as an assistant by the iconoclastic designer and businessman Pierre Cardin. The young Gaultier would work for various houses in Paris, and again for Cardin in the Philippines, before making his solo debut in 1976. Gaultier set out to champion ready-to-wear – a category only recently recognized by the Chambre Syndicale – and to make merry with stiff and boring bourgeois attitudes and aesthetics.

It was tough going in the beginning, but with the support of the Japanese company Kashiyama, Gaultier got on his feet. His 1984 'Barbès' collection, featuring cone-breasted velvet dresses, was a breakthrough. The same year, he launched menswear. Those who thought men in skirts were scandalous had another thing coming. In 1990 Madonna tapped Gaultier to design costumes for her *Blond Ambition* tour. The corset with pointed bra that he dreamed up for her pushed Gaultier into the stratosphere. That decade was the designer's Golden Age. With collections like 'Chic Rabbis' and 'Tattoos', he aroused shock and awe. And then, in 1997, he decided to take up couture, shaking up tradition by offering options for women and men, thus maintaining an anti-establishment attitude in a traditional *métier*, in which he put time-tested technique to new use. The legendary house of Lesage embroidered Gaultier's own upcycled jeans for that first outing.

Somehow the designer also found time to design for movies, including *The Cook, The Thief, His Wife and Her Lover* (1989), Pedro Almodóvar's *Kika* (1993) and *The Fifth Element* (1997), and to co-host the British television show *Eurotrash*. The recipient of many awards, Gaultier was named a Chevalier of the Order of the Legion of Honour in 2001. Then, from 2003 to 2010, he was the creative director of Hermès. His first collection for the company included a leather corset featuring one of the house's signature padlocks. Having found success with fragrance early on, in the late aughts he introduced makeup for men.

Costume design was a natural extension of the designer's penchant for the performative. He often incorporated elements of dance into his runway shows, and collaborated with choreographers including Régine Chopinot and Angelin Preljocaj. In 2018, Gaultier developed his *Fashion Freak Show* – a semi-autobiographical revue.

Puig took a majority stake in the business in 2011, and the designer said goodbye to the runway with a retrospective extravaganza presented during the Spring/Summer 2020 couture season. With nostalgia leading culture, interest in the designer's body of work only continues to grow. Capitalizing on that, Gaultier introduced a guest designer programme, whereby he invites a colleague to design a couture collection based on his own breathtaking archive. It was not a goodbye after all, but rather the opening of a new chapter for an ever-inspired – and inspiring – storyteller.

The Collections

Biker of the Opera

On 21 October 1976 Jean Paul Gaultier, greatly inspired by the British punks, threw down his gauntlet and challenged the existing French fashion system. As if to emphasize that this launch would not follow a predictable orbit, he staged his show at the Planétarium du Palais de la Découverte.

In her book, *Avec l'ami Jean Paul Gaultier*, Anna Pawlowski, one of the nine models in the show, included a photo of herself barefoot wearing an unexpected combination of leather and tulle (see opposite, top left), and looking for all the world like an updated version of Edgar Degas's circa 1880 sculpture *The Little Fourteen-Year-Old Dancer*. Its subject posed for Degas with her chin thrust up into the air, projecting an air of defiance. In this she was aligned with Gaultier's early solo efforts.

The designer was pushed from the *corps de ballet*, as it were, and into the spotlight by his great love, Francis Menuge, who encouraged Gaultier to launch his own line. Friends and family pitched in to help; as a 2011 *New Yorker* profile reported, Gaultier's 'cousin Évelyne knit the sweaters, the concierge of his apartment building helped with the sewing, and Menuge made the accessories and handled the business arrangements'. Gaultier's debut collection included denim looks remade from jeans in his own wardrobe. In the catalogue for his 2015 exhibition at the Grand Palais, he recalled that 'for lack of money, I had created my first collection of prêt-à-porter with fabrics bought at the Marché Saint-Pierre: jackets from tapestries or placemats in woven straw, canvas piping, toile de Jouy for furniture, a biker jacket with a graffiti "1976" on the back, worn with a dancer's tutu and sneakers. Total rebellion.'

Pawlowski's *On the Waterfront* meets *The Red Shoes* outfit is a good example of Gaultier's penchant for the collision of opposites. Also introduced in this collection was the long-waisted line that the designer would return to again and again. This was used in an ensemble made from placemats from the Philippines that were transformed into a tie-front bolero; a thick canvas strap defined the natural waistline, and then the skin was exposed until the raffia waistband of the skirt, which sat low on the hips (see opposite, bottom right). Though not for the demure, this design was not an outlier in a season of exposure; as a *Montreal Star* headline exclaimed: 'New Paris Designs Give Skin No Place to Hide'.

Robin Hood

Perhaps making a direct allusion to the resourceful spirit of his previous show, Jean Paul Gaultier took both title and inspiration for this presentation from the 1938 classic film *The Adventures of Robin Hood*. Much like the savvy outlaw, Gaultier enlisted the help of a band of friends and family to knit the oversized sweaters seen in this collection, while various models, hairdressers and makeup artists offered services free of charge. 'The trouble was, we knew nothing about marketing clothes,' Gaultier later explained to *The Washington Post* in 1984. 'All of us were working very hard, yet financially we seemed to be going nowhere, though the fashion press thought we were great.'

Rather than the 'softly feminine look' comprised of 'flowing, swirling, wafting' garments popular that season, as one reporter for the *Pittsburgh Post-Gazette* observed, Gaultier's models appeared in oversized woollen jackets and quilted linen, paired with knee-high woollen socks, or similarly high leather boots. Medieval-esque knitted tunics were worn over tights, and felted hats might have been plucked straight from Sherwood Forest. Fur also featured heavily, made in India with a furrier company with which Gaultier was working at the time.

Cinema would, of course, continue to be an enduring inspiration for Gaultier, with subsequent collections inspired by *Grease* (see p. 36) and James Bond (see p. 38).

Renaissance

Titled 'Renaissance', Jean Paul Gaultier's
third collection avoided gilded ostentation
in favour of an earthy take on the era. Sandro
Botticelli's masterwork *Primavera* might
have been the inspiration for the fresh white
dresses, or, indeed, the floral prints. Models
wore espadrilles; some had fresh flowers in
their hair, others large straw hats hanging
down their backs. Novelty accessories
(a maraca) and materials (actual fishing nets)
provided narrative clues and gave context to
pants with paper-bag waistlines and striped
jumpsuits. Gaultier was conflating the
idea of rebirth with the escapism of sunlit
summer vacations.

Though the bikini originated in France in
1946, it really became enmeshed in pop
culture iconography when a then 18-year-old
Brigitte Bardot was photographed wearing
one at the Cannes Film Festival in 1953. BB,
as she became known, would later popularize
gingham (aka Vichy check), a pattern Gaultier
used for his Spring 1978 collection, in a
season in which, reported the Australian
newspaper *Le Courrier*, 'Le Style Brigitte
Bardot' was being revisited on a wider scale.

Gaultier applied a mix-and-match
approach to ideas, materials and eras –
even down to the scenes on the toile de
Jouy fabric, which featured bikers, rather
than the typical pastoralia. The collection
juxtaposed an early '50s prim-ish prettiness
with something darker through his use
of latex, for one. A model yanking a scarf
alarmingly tight around her neck and another
carrying a whip introduced a different kind of
sex appeal, the BDSM references associated
with punk. Not one to get too grim, the
designer introduced circus-like aspects
into the collection via such garments as a
tent-like jacket in wide multicolour stripes
(see p. 32, left). Jewel-toned tapered pants
with vertical bands of elastic that created
balloon-like poufs down the legs were a
fine bit of Gaultier clowning.

Ska Poets

Jean Paul Gaultier's Autumn/Winter show
looked towards the radical energy of London's
emerging punk, ska and New Wave scenes.
Augmenting the season's popular trouser
silhouette – full and pleated at the top, narrow
at the bottom – with a slash above the ankle,
Gaultier added a flash of New Wave romance.
The designer's two-tone colour palette was
perhaps a nod to the so-called 'two-tone'
groups of the British club scene – a sub-
genre of ska, named after the music label
2 Tone Records.

Bold accessories dominated Paris's Autumn/
Winter presentations, with Marian McEvoy
noting that 'the key to French accessories
is obviously the obvious'. Here, the model's
quilted leather gloves – gauntlets, almost –
ever-so-slightly frizzy hair and bold lip
place her as having walked straight from
a New Wave club onto the catwalk.

New Wave – and London's counter-cultural
movements in general – would continue to
inspire Gaultier, with references appearing
in later collections including 'High-Tech'
(see p. 44) and 'Sorceresses' (see p. 52).

Grease

How could Jean Paul Gaultier not fall for the 1978 Hollywood blockbuster *Grease*? Not only did it play up opposite types and styles – 'good'/'bad', greaser/letterman – but the happy ending, in which love wins, involves sartorial modifications. The designer first came to know, and believe in, the magic of clothes through his beloved maternal grandmother, Marie Garrabe, who altered her shape with the aid of corsets. Watching her do so, Gaultier later told *The Telegraph*, 'I became fascinated by the idea of transforming one's body with clothes.'

One of the ways the film was absorbed into the collection was by casting. Anna Pawlowski writes that the 'three bad girls of the Palace [nightclub]' – Edwige Belmore, Frederique Lorca and Farida Khelfa – walked the show. Presumably they were a Gallic version of the Pink Ladies greaser gang. The model-turned-author describes the collection's aesthetic as 'retro/modern', and it was indeed a playful, time-warping lineup. Gaultier sent poodle skirts with huge petticoats, referencing the era depicted in the movie, down the catwalk, as well as the first appearance of tops that exposed lingerie (though in fact each construction was made as a single piece). He said he was inspired by girlfriends who would intentionally let a bra strap show.

James Bond

Having explored the American love- and coming-of-age story *Grease* for Spring/Summer 1979 (see p. 36), Jean Paul Gaultier took on a different genre for Fall. He imaginatively hopped the Pond in pursuit of one of the most-wanted men in all of fiction: the square-jawed, Martini-drinking, Savile Row suit-wearing British Romeo and Secret Service agent, James Bond, from whom the collection takes its name.

Given the inspiration, it's no surprise that there was a lot of tailoring on offer, some of it with a corporate 'dress for success' edge. The designer adapted some aspects of 007's style for women; models wore masculine-style footwear, for example. Gaultier also played with the inverted triangle silhouette, making shoulders broad, waists small, and minis micro. The *Daily News* reported that a model wearing one of those super-short skirts with a seven-eighths-length coat 'looked like she had nothing on', at the same time noting that Gaultier was 'a new idea man'. This was not a case of the Emperor's New Clothes, in other words. In any case, being able to hide things and to create distractions are among a Bond Girl's assets, no?

This collection was not all business, however. A feeling of sporty adventure was conveyed through ski-inspired leather jumpsuits, bomber jackets in velvet and a hooded dress in green paired with a purple baseball-style jacket and a red scarf (see opposite, bottom left). It was cool, in a way that couldn't be measured by a thermometer.

The Divers

In these early years, Jean Paul Gaultier's collections were evolving as he was, and ideas carried over from one season to another, as he refined his vision. On the heels of the James Bond collection (see p. 38) came 'The Divers' collection with its wetsuits and fins that evoked an underwater adventure... and sex. Think Ursula Andress as Honey Ryder in *Dr. No*. That film was released in 1962, which seems somehow significant, as there were a good number of Courrèges-isms in this lineup (lots of white dresses and go-go-like boots).

At the time, much ado was made over Gaultier's mini-skirts. *The Leicester Mercury* described them as 'bum-freezers'; meanwhile, Liz Smith in the *Evening Standard* wrote, 'This is post-punk Paris – not so much a return to the mini as another expression of the well-turned thigh', but even she acknowledged that designers were looking back to the Youthquake era. Many of Gaultier's minis were worn with white tights and flats, and some models carried pinwheels; taken together, this was a play on the wide-eyed, coltish Twiggy, mascot of the early '60s. Keeping things up-to-date were New Wave embellishments in the form of candy-coloured confetti.

Gaultier was raised by parents who lived through the Second World War, and there is something of the 'make do and mend' mindset in his 'everything but the kitchen sink' approach to DIY, which differs from the punk ethos. Some of the gloves in this collection might have been used for dish-washing; the florals might have been inspired by disposable tablecloths. Smith noted the cheapness of the fabrics: 'Gaultier's high-voltage collection caused ripples of shock to run through the audience with his sleazy cire and satin fabric, his short hemlines and super-slim outlines.' The coexistence of breeches and New Wave bodysuits is perhaps even more surprising. With the benefit of hindsight, it becomes clear that the takeaway here is the appearance of innerwear as outerwear: laced corselets were layered over separates, in a first hint of what was to become a Jean Paul Gaultier signature.

High-Tech

France has set many cultural watermarks, but few of them relate to youth culture. London, not Paris, was the birthplace of the Youthquake in the '60s, a time of post-war prosperity. It was also the homebase of subcultures that emerged during periods of economic contraction, including punk, New Wave and the New Romantics. As influential as British fashion was, Paris remained the industry's main stage, with an accompanying sense of pride and propriety. Here, it was possible to shock, and that's just what Jean Paul Gaultier did, becoming the one, claimed the *Montreal Gazette*, to bring 'the first touch of Paris Punk-New Wave to the Pret a Porter shows'.

As the vibe was based on a DIY aesthetic, the title of this collection, 'High-Tech', should be read ironically. Gaultier yoked this youthful alt-energy to a sort of 'make do and mend' approach. An oversized safety pin pierced through a sequin mini-skirt with a generous side slit (see opposite, top right) was a sign of punk solidarity. Being a Frenchman, the designer also took inspiration from the *métiers* of cuisine and couture, turning wire mesh tea-strainers into earrings and shiny tin cans into armbands, and stringing their disc-shaped tops into necklaces. 'His clothes are amusing and reflect what is going on in young circles,' noted *WWD*. The effect was youthful and fun. 'His mannequins were about 16 years old and carried number cards reading "22" or "356,897" to spoof couture shows,' *WWD* continued. 'His look is a mix of "Star Trek," the high Courrèges-Cardin Sixties, New Wave, and the Bains Douches discotheque.'

Gaultier would revisit this couture tradition of identifying looks by number cards throughout his career. It was a way of allying himself with the rapidly developing prêt-à-porter. (Two decades before, in 1959, Gaultier's mentor Pierre Cardin had been expelled from the Chambre Syndicale for creating an off-the-rack line for Printemps department store.) Layered parkas and stirrup pants added a vaguely winter sports aspect, and faux fur jackets appeared in super-bright colours, described by Gaultier as his shouty take on the Chanel jacket. Both men and women wore kilts, and a metallic plaid skirt worn with a Pierrot-collar blouse (shades of Lady Di?) and velvet moto (see p. 47, bottom left) offered a new take on festive dressing, as did the cake that was walked down the runway and eaten backstage (see p. 47, right).

'High-Tech' is an odd name for a collection in which some tunic dresses had a vaguely medieval feel, but those number cards were rendered in an alarm-clock font, and they also recorded temperatures, as in '37,6°'. In addition, Gaultier went state-of-the-art in the form of manmade materials like plastic and vinyl, even integrating circuit boards (see right).

Paper Summer

Paris is no stranger to mobs; still, the
press couldn't help noting the size of
the crowds pressing to attend Jean Paul
Gaultier's shows, not in protest, of course,
but in appreciation. Part of the designer's
appeal, in the opinion of a reporter for the
Montreal Gazette, was being identified
as 'an anti-fashion person' (read: against
the establishment). 'To a sound track of
"La Poubelle" (the garbage can), he pokes
fun at hippies, yippies, stoneys and phoneys,'
the writer continued; he 'is well on his way
to being this decade's revolutionary spirit'.
But not without bringing along some of the
spirit of the decade of his youth, the '60s.

In this show, titled 'Paper Summer', models
wearing dresses of paper – a fad in the
Swinging decade – were accompanied down
the runway by workers who carried scissors
and used them to refashion these crinkly
frocks right on the catwalk. This was but one
antic among many: male 'twins' were cast to
walk in the show (one pair in dresses) as well
as a Cupid, outfitted with paper wings and
a bow and arrow. Jean Paul Gaultier's beloved
partner Francis Menuge also made a runway
appearance (p. 51 top left, Menuge is on
the right).

Carried over from the previous seasons
were paper-bag waistlines, this time
with a more fantastical flair, one pair worn
shirtless (à la Gauguin?). Among the common
household goods made into accessories were
copper pot-scrubbers, and silvery outdoor
survival blankets transformed into jumpsuits
and rompers. Newer were layered knit looks:
a cropped wrap top worn over a longer top
tucked into leggings with a rolled waistline
(see p. 50, bottom right) had an off-duty
dancer feeling that married disco and the
sportif. Contrary to the softness of this
way of dressing was Gaultier's introduction
of military elements like patch pockets,
camouflage print and gun-casing necklaces.
And, with a punk gesture, the designer
styled a Sam Browne-style belt upside-
down (see right) so that the shoulder strap
passed between the legs, perhaps as an
anti-war statement.

Sorceresses

In the early '80s there was a feeling
that the Paris fashion industry was under
'attack' from at least three sides – the
rise of Italian fashion, the innovations
of the Japanese designers showing at
the prêt-à-porter, and a sluggish French
economy – and was in need of some magic,
and youth. Jean Paul Gaultier delivered
on both counts with a British-inflected
collection, 'Sorceresses', that was, reported
journalist Iona Monahan, 'New Wave in [its]
best sense'. It was camp as well.

Performing live in front of an open casket
was the Moroccan-French singer Sapho,
dark-haired in a dress dramatically hung with
plastic skeletons (see p. 55, top right). These
figures were used as earrings and as a belt
on an all-black ensemble consisting of velvet
leggings paired with a sequinned top and
leg warmers that was representative of the
more body-conscious look of this season
(see p. 55, bottom right). Pitchfork brooches
pierced fabric ties, used as head and hair
wraps, and models' faces were powdered
and featured *mouches* pulled from the suits
of playing cards; Goth-meets-jester, perhaps.
Some of the most winning looks in the show
were the outerwear pieces, such as a men's
moiré parka with a drawstring waist worn
with a bowtie (see p. 54, top left). Women's
toppers came in paisley prints, one almost like
camouflage; another version had a pixellated
look. Wonderfully cut jackets were tucked into
pants, paired with culottes, or cut cropped
and worn with shorts: they fit like a charm.

Romantic Angélique

It's possible to tease out five or six main strands from this very broad offering, its title inspired by a series of French romance novels, 'Angélique in Love'. Inspiration came from the draping of antique togas (see right); meanwhile, workwear was given a high/low remix in the case of overalls cut from moiré – by now a house staple – instead of denim, but it appeared in more traditional forms as well. A fellow in a blue coverall, for example, escorted a woman in a similarly hued work jacket (see p. 59, top left), a sort of variation on the classic French model that fashion photographer Bill Cunningham made his uniform. There was also a military-meets-pirate theme, with breeches, camouflage, and Sam Browne belts that acted like masculine counterparts to sturdy garters visible through sheer designs.

Exposed bras and girdles were armour- or machine-like, some bearing a resemblance to the fins of 1950s automobiles. It was this decade, noted *WWD*, that Jean Paul Gaultier was channelling with his hourglass silhouettes, and this collection marked one of the first appearances of his bustiers (see opposite, bottom right). The designer 'took a Fifties theme – tight, sexy skirts, pedal pushers, slinky tops over visibly padded bras – and made it his own. Though he has done away with the beer-can earrings and the paper dresses [see p. 48], Gaultier is still afraid American buyers won't understand his clothes, and so he didn't invite any.'

Skirts filled out by petticoats were variations of the fit-and-flare shape introduced by Christian Dior post-war, but the tulle number paired with an off-the-shoulder denim jacket (see p. 59, bottom left) was a nod to the key look of Gaultier's debut collection (see p. 26).

The deconstructions here are particularly noteworthy (and pre-date Martin Margiela's arrival as design assistant at the house in 1985, allowing us to trace Gaultier's influence on the Belgian designer). Lining fabric was used for sleeves on jackets with wool bodies; other toppers, with the inner labels showing, appear to be worn inside-out (see opposite, bottom left) – this was no mistake, but by design.

Gaultier's Paris

This collection is known by two titles, 'Gaultier's Paris' and 'The Existentialists', but it's the former that fits best. You could argue that this season was about existence in the specific – and mythologized – tradition of the French *flâneur*, who absorbed the world around him while walking the lively streets of Paris.

Entertainment, of various Parisian varieties, seems to have been the red thread here. While suggesting that fashion is a three-ring circus, this show was also a promotion of ready-to-wear, and of Paris. It's here that Gaultier first makes use of the Eiffel Tower, a symbol that would come to be attached to the house like a tattoo. This marvel of the Industrial Age swung from earlobes and could be peeked through mesh-like bags; there were Eiffel Tower heels as well as a sequinned dress with the motif in red on the back. The *Los Angeles Times* reported: 'In a flag-waving season for French fashion, the national anthem has replaced American disco music on the runways. The idea, it seems, is to replace American sportswear with Parisian chic.'

It was the case that the French were facing stiff competition from Japanese designers showing in Paris, from Milan, and from the US. Still, the Parisian chic Gaultier touted wasn't of the Birkin bag and *foulard* variety. 'If designers really get their inspiration from the streets of Paris, then Jean Paul Gaultier has been hanging out at Pigalle. His clothes are very sexy, cupping the derriere in a tarty French Cabaret style,' wrote the *New York Daily News*. The garter belts of the previous season were attached to armour-like belts, this time made in tricot with built-out rounded edges. There were corset tops and sheer leotards as well, but this collection was less about sex than about spectacle. There was a circus-like aspect to the goings-on, with some models bursting onto the runway through paper-covered hoops. The soutache trim, tails and bright colours associated with ring-masters and other circus folk were also part of the collection.

Dada

Jean Paul Gaultier's Spring/Summer 1983
collection takes its name from the radical
art movement Dada, and on that theme it
offered looks that were deconstructed, cut
up and rearranged. Cropped tank tops and
cargo-pocket bras were over-layered, pants
were doubled so it looked like the model
had forgotten to close their fly and a female
model wore undone trousers that exposed
man-style briefs. Every reveal was strategic:
these apparently separate items were all in
fact designed as one pieces.

The release of Rainer Werner Fassbinder's
film *Querelle*, featuring sailors and brothels,
made a big impact on the designer, and the
sheer tank tops in this collection mark the
first time Gaultier presented his iconic navy
stripe. Other naval touches included centre-
zipped berets and ditty bags.

Military motifs and a fluffy feather and
mosaic tile print aside, this collection
was strong on proportion play and lingerie
dressing. Crop tops and harnesses divided
the torso into geometric planes, while
off-the-shoulder top layers revealed the
slender linearity of tanks worn underneath.
Alternatively, girdle-like belts rose up
close to the hem of bandeau bras.

In another seminal Gaultier moment, the
corset first appeared: to-the-ankle back-
laced corset dresses and jumpsuits made of
salmon-pink satin with quilted conical busts
were instant standouts, accompanied by
camisole and tap-pants separates. Some
models untied from around their waists what
turned out to be sheer sequinned dresses
that they slipped over their satin underthings.
In other instances, Gaultier preferred to go
down instead of over. As the *Los Angeles
Times* observed, the designer 'puts his spring
heroine into dresses cut with necklines
so wide the bodices fall down to the waist,
revealing tank-top or slip-top blouses.
The models tie the fallen bodices around
their waists as belts.'

Going the opposite direction – up – was the
veil of the bride, lifted as it was by a bevy of
balloons (see p. 71, bottom right). Gaultier's
antics were evidence of a shift in fashion.
As Iona Monahan, reporting for the *Montreal
Gazette*, noted: 'The gap between the old and
the new is ever widening in Paris, with status
designers like Givenchy, Scherrer, Gres, and
even Pierre Cardin moving into semi-fossilized
positions. The fashion changes which are so
essential to the survival of the world's fashion
industries no longer come from designers
of that ilk. They come from the irreverent
creators: Karl Lagerfeld, Claude Montana,
Thierry Mugler and the even younger rebels,
Jean Remy Daumas, Jean Paul Gaultier,
Marithé and Francois Girbaud.'

Trench de Vie

The trench coat – a garment that would be
a pillar of Jean Paul Gaultier's work – was
centre stage this season. Offered in metallic,
as a bodysuit, these outerwear garments,
first designed for military use, also carry
associations with protection (from the
elements), espionage and flashing. Gaultier
seems to have been inspired by the trope
of a man opening his coat to reveal a lining
hung with watches (and often his body) to
create jewelry with metal discs that look
like the inner workings of a timepiece.

The passing of time was also marked by the
changing scenery. Models walked against
a yellow set bearing a black logo. During
the course of the parade, 'Judex' was
spray-painted on that wall. It's the title of
a 1963 film, which is a remake of a movie
of the same name from 1916, based on the
eponymous pulp fiction character, a kind
of Robin Hood (who inspired the designer's
second collection; see p. 28).

The styling of models in chauffeur caps added
a bit of a *Night Porter* vibe to the proceedings.
Certainly the models appeared less secretive
than sexy; especially those in black satin
corsetry worn over lace.

The title of the collection is a play on the
French phrase, 'tranche de vie', or 'slice of
life'. Gaultier seems to have translated this
literally into garments that are split open, or
left unbuttoned; though, as with his previous
collection, these deconstructions are in
fact sewn as single pieces. Similarly, some
'pockets' are simply slits (the models' hands
go right through; see p. 75, right). However,
there's no accusing the designer of coming
up empty here; the tailoring was marvellous.

The Return of Prints

'Fin des idées noires' announced Jean Paul Gaultier with his Spring/Summer 1984 collection; this explosion of colour and print marked the 'end of the dark mood', his reaction against the all-black Japanese fashions that had come to Paris.

Perhaps the best-known piece from this collection is the 'Fez Mysteron' hat designed for Gaultier by Stephen Jones, as it was drawn by Tony Viramontes. Made of felt, it has a liquid-like fringe that falls through the eyes (see opposite, bottom left). If they are meant to be tears, then they are tears of joy, for this was an upbeat collection that delivered a smorgasbord of themes pulled as if from a grand bazaar. Hats, tassels, mosaic prints, sari-like wraps and spice-like colours spoke of the East, while plaids referenced the kids on the street in London who were so inspiring to Gaultier at this time. Jones later recounted: 'In 1983 I got a phone call. Jean Paul wanted me to model for his first men's show. I wish I could have, but unfortunately I had twisted my ankle in a motorbike accident. He had seen me in the Culture Club video "Do You Really Want To Hurt Me?". In it I was wearing a fez with a vintage zoot suit. It provided him with inspiration for his "The Return of Prints" collection's show.'

In conservative, siloed France, Gaultier was stirring the pot and serving up a global and cross-genre mix with both his clothes and casting. Speaking to *The New York Times*, Daniel Rozensztroch, a young French creative, said: 'In fashion there is Gaultier, who represents a new generation here that loves fashion but realizes it is not an isolated phenomenon giving birth to ball gowns every other second. The new view is that fashion is a design form and should be mixed with interior design, theater and film to become part of a design whole. The Government is supporting this.' There was a sense that France had to reclaim its superiority in matters of culture, but at the same time not return to form. Enter Gaultier with his inclusive and androgynous designs, his appetite for difference, and his seemingly innate ability to *épater les bourgeois*.

Like the Pied Piper of Hamelin, he attracted a crowd. The *Montreal Gazette* reported that: 'A clique of young fans, dressed in the big, bright, clown-colored, plaid suits that have become [Gaultier's] trademark, jammed into every available bit of tent space on one rainy night (at least a dozen really did hang from the rafters!)'. Another reporter observed that 'the French came up with a hero of their own: Jean Paul Gaultier. The scene of his show was chaos, with fistfights, police, rain and shouting. Those left outside pounded the doors. Inside, the air was dense with smoke. The clothes were worth the fight, even if they were not totally wearable.' Unmissable and unforgettable, however, they were.

Barbès

'Barbès' was Jean Paul Gaultier's
breakthrough show, the one in which
he crossed over into the big leagues
with a collection that was in many ways
a summation of all that had come before.
While Thierry Mugler lowered a Madonna
from the ceiling (in the ethereal form of
model Pat Cleveland), Gaultier chose
to have a gospel choir perform at his
'baptism' into the higher echelons.

The most exhibited looks from the collection
are surely the ruched velvet dresses with
the exaggerated cone bras (see pp. 88–89).
The *Los Angeles Times* described them as
'freak-show dresses featuring seven-inch
bosom appendages shaped like nuclear
warheads', and the *Daily Mirror* saw them as
'jokey look[s] for girls wanting to emphasize
their charms'. This was pre-Madonna, mind
you. And it was less the breasts than the
gathering that linked them back to the
rest of the collection.

'Barbès' is the name of an area in Paris known
for its cosmopolitan population, with many
immigrants from Africa and northern Africa,
especially. Gaultier took inspiration from
the people in the area who wore traditional
African clothes mixed with Parisian winter-
garb. Everything was layered, even the socks
and gloves. Depending on the source, other
influences included the designer having
tripped over a man sleeping on the street who
was wearing a sweater over his coat (*WWD*),
or London fashion, or an everyday gesture.
'He says he was inspired by the way sleeves
look when you push them up,' reported
Marylou Luther. 'By studying what kids do to
their clothes in the normal course of dressing
and playing,' she continued, 'Gaultier has
come up with: skirts with horizontal folds
not unlike the look of pushed-up sleeves,
shoes with scrunchy folds, backless dresses
cut low enough to reveal red velvet
scrunched-up panties.'

There were many distractions, including
clashing plaids, nomadic headdresses, even
a Cruella de Vil impersonator, that threatened
to take the attention off the main story here,
which was essentially reimagined classics.
Take away the Japanese influence in some
of the drapier pieces and you are left with
an oversized polo shirt, a hoodie worn under
lace (see p. 86, bottom left), and remixed
three-piece suits. As *WWD* noted, Gaultier
'used a panoply of sophisticated tailors' tricks
to create meticulously crafted clothes that
give the illusion of not fitting at all'. That's
the thing with Gaultier: first impressions
and surfaces never tell the whole story.
From his grandmother, the designer told
WWD, 'I learned the importance of physical
appearance as it relates to the interior
life – the importance of attitude, gestures,
movement, and how everything is connected.'
Substitute 'construction' for 'the interior life'
in the above quote, and you get the gist of
what powered this collection.

A Wardrobe for Two

When the doors to Jean Paul Gaultier's Spring/Summer 1985 wardrobe were opened, what emerged were not only new mix-and-match garments, but also members of a new coterie. 'The people who wear these either/or fashions are being called "third sex" because they represent a new fashion species – one sworn to neutering the gender of clothes,' reported the perspicacious Marylou Luther. But here she was only partly right: Gaultier was not trying to erase or ignore gender. As he told journalist Sally Brampton, 'My clothes are not about androgyny, not about uni-sex; they are about sexual equality. Men can be glamorous, they can be fragile and beautiful too. They have to be sexy and seductive today. Women are waiting for that.' As were other men, but Gaultier didn't articulate the queer aspects of his work. He did, however, cast the British singer Marilyn and Stephen Sprouse's transgender muse, Teri Toye. This was concurrent with Boy George's popularity, which had a reach that extended way beyond fashion, although Brampton noted that 'there were five sets of steel crash barriers, an army of security guards and a wildly vociferous audience of thousands' clamouring to attend the fashion show. The lampshade dresses were created for what *WWD* described as an 'entr'acte ballet', and trouser-skirts for men re-appeared on the runway a few months after Gaultier had debuted them in his menswear show.

Not only did Gaultier's 'fashion tribe' define new territory when it came to gender, but geo-political borders didn't seem able to contain them either. This collection made references to African traditions (Masai necklaces, mask embroideries) as well as Southeast Asian ones. The midriff was the focus here, and models' middles were painted in earthen tones of red and ochre. Corset sheath dresses featured sari drapes. This collection was an overt culture clash. Besides the ethnic/national aspects at work here, performance-looking fabrics and sneaker-platform hybrid shoes were mixed with punk plaids; pinstripes strayed from Savile Row; and lingerie, as usual, came out from under. Backs were exposed as well. Some jackets had backs shredded into fringe (see p. 95, bottom right); others had the sides cut away, leaving only a 'spine' bisecting the back (see p. 95, top right).

Among the most emblematic looks from the collection were the berets (a symbol of France) hung with tawdry tourist trinkets. This was iconoclasm, a message that said that the country, and its famed fashion, was bigger and more diverse than what was 'correct'; that Paris, much like individuals, or garments, could contain multitudes.

The Uptight Charm of the Bourgeoisie

In some senses, Jean Paul Gaultier's deconstructions of the fashion system were an 'inside job'. The child of a marriage between a working-class man and a bourgeois woman, the designer had a 'classical' education at the *maisons* of Pierre Cardin and Jean Patou. His rejection of the haute couture, in favour of the prêt-à-porter, propelled much of his work. Having spoofed the format of the former several times, for Autumn/Winter 1985–86 he turned his attention to the clients.

WWD recorded the scene, writing that the show 'was presented as a series of vignettes that took a comic-strip view of the sort of haute-bourgeoise matrons who reside on Avenue Foch or Park Avenue and included a French comedienne who delivered a treatise on high fashion in the persona of an old mannequin, a male soprano who performed for a salon assemblage of very blasé guests and a New York smart-set woman who droned on about her problems with her psychiatrist'. It was the mannequin, noted the reporter, who issued what was a kind of mantra for the goings-on: 'Life is reversible.'

This was not a *Belle de Jour* that revealed what goes on behind closed doors; rather, it was about what lies behind them. Black leather coats reversed to prints more common to interiors than fashion. As one critic noted, Gaultier 'can take credit for the spread of the use of upholstery fabric and chintzes in fashion'. Sweaters featured fringes and passementeries more often seen trimming sofas and pillows. And the most romantic looks, which were quilted, resembled traditional French *boutis* needlework.

The 'skeleton' jackets of the previous season (see p. 90) returned, as did the designer's favoured tri-partite silhouette; this time mid-sections descended over the hips. Breasts were deflated in some looks, and emphasized by gilded sculptural bras (see p. 98, bottom left) in others. The cone was adapted for use in Aran-knit sweater dresses (see p. 100, bottom left). Nice bait indeed.

Dolls

'I tried to make a new expression of folklore from its French origins,' said Jean Paul Gaultier of his 'Dolls' show. In another rather enigmatic interview he stated that the lineup represented 'a return to moral values'. If there were a return to anything, it was to the Island of Misfit Toys. Models wore nets over their heads, through which a comb-stabbed top knot emerged.

Newsday reported that opening the show was 'a model swathed in an elongated white tutu that made her look very much like a jack-in-the-box [who] performed a kind of avant-garde ballet before she retreated into a huge wooden toy chest at the rear of the stage [see opposite, top right]... Some models at Gaultier's show carried dolls as they paraded pirate-cum-peasant looks.' Expanding on this, the newspaper later noted that this 'crazy, sometimes sexy ballet' was enacted by '1985 Captain Hooks with Madonna-kins as their pirate queens'. There were 'Like a Virgin' references in charm belts and tulle skirts, most of which were worn under skirts that exploded with net at the bottom. Other skirts were gathered, then ballooned out over a slimmer stem of ruffles. These topiary-like clipped tulle looks, including one with a cone cod-piece, were in fact real costume pieces, designed for the famed choreographer Régine Chopinot's ballet 'Le Défilé'; in return, some of her dancers appeared as models on Gaultier's runway (see p. 107, bottom right).

For all the froth of this show, there was a good deal of tailoring in all black or black and white that seemed influenced by the Japanese. The torso-printed *marinières* were pure Gaultier and their association with the sea might explain why some models carried pipes as accessories. Lacing was vaguely Tyrolean and fit into the folklore theme.

Gaultier's antics drew thousands to the suburbs to see the show. '[He] has always had an outrageous, cartoonish showbiz approach,' noted the Associated Press. Camp, with its association with queer culture, is perhaps a more succinct way of putting it. And the public ate it up. As the Wire Services noted, Gaultier 'is worshipped by young fans the way others sigh over rock and film stars. He shocks some and amuses others. And it's good for business.' The brand opened a boutique on rue Vivienne that year.

Constructivism

In her 2018 dissertation, scholar Doris Domoszlai-Lantner declared Jean Paul Gaultier's Constructivism to be an expression of 'fashnost', using a word coined by a *Vogue* columnist that plays both on the idea and sound of the policy of *glasnost* (openness) proposed by Mikhail Gorbachev, who had been named president of the Soviet Union just a year earlier. The Russian influences the designer tapped into dated back to the 1910s, when the art movement was founded, to reflect the industrial aesthetic of urban society.

Gaultier specifically referenced the work of Alexander Rodchenko, one of the founders of Constructivism, referring to both the artist's graphic work and photography. The Frenchman used his own baby pictures for the purpose; and in some cases the Cyrillic lettering spelled out his name. The paintings of Kazimir Malevich, who is known for depicting stoic figures in striped and colour-blocked garments, also had an impact on this collection, which was easy-going in terms of presentation but notably stricter in silhouette. As Geraldine Ranson put it in *The Sunday Telegraph*: 'His romantic fantasy world has evaporated, and there is a new realism [in his garments].'

There wasn't a total about-face, though. Scuba-fit dresses had embroidery of concentric circles at the bust, but they were less dimensional. The palette was more muted, and tailoring came to the fore, as did colour-blocking, some of which was created through the use of two-tone double-face fabrics. The designer described the lineup as being 'more simple, more modern. Finished is all the superimposition of clothes – one on top of another. No, it will only be one dress and one coat... one dress and one jacket, things like that. It's a little like a collection I did in '78. It was my James Bond collection [see p. 38]. It will not be a '60s look – just a little similar in its simplicity.'

The show was impactful in its multiplicity. A cast of about 100 models presented the new season in a cavernous space with double-height scaffolding, on which they gathered and socialized after each completed their passage (it was a one model/one look type of show). Among the models were several Gaultier team members, including design assistant Martin Margiela. Some critics saw the collection as having a militaristic aspect, but in the same *Montreal Gazette* interview quoted above, the designer clarified his intent. Asked 'Why Russian?' he responded: 'Why not Russian? Only for the graphism, because it is beautiful. I find Russian graphism and Russian constructivism nice, it's not political, nothing like that.'

Nothing by a
Good-for-Nothing

In this period, each new Jean Paul Gaultier collection carried forward elements of the preceding one, or reintroduced ideas from earlier offerings. In this case, the graphic elements of Autumn/Winter's Constructivism show (see p. 108) were applied to sportswear. There were number jerseys that read '52', a reference to the designer's year of birth, as well as baseball jackets in various iterations. A black and white checked leather topper was said to look like a deconstructed soccer ball, and many models wore lidded caps. Leggings and *maillots* were part of the offering that also included suits with very tight capri-pants rather than trousers. Observers saw this outing to be something of a 'stock-taking' moment. '[I]f some people say I make a retrospective,' Gaultier told Toronto's *Globe and Mail*, 'it proves that in some way I have a style.'

The staging was dramatic. 'Hearts missed four beats when a huge white stage curtain rippled up to reveal a black gaping stage full of "Thunderbird" lookalike models, who were then spat out one by one on to a revolving platform,' wrote *The Observer*. The presentation was orchestrated to highlight the individuality of the motley cast containing many body types. Gaultier wrote in the programme that: 'The show is entirely dedicated to the personality. Everything is erased but the fabrics, the colors, and the way to wear them.' *The Observer* noted, 'There were geeks, sex bombs, wallflowers, studs, and floozies.' The models did their own hair and made their way down the runway, 'walking, running, dancing, doing whatever they wished. His philosophy: People make the clothes, not the other way around,' the *Chicago Tribune* reported.

A model wearing a red corset dress 'accessorized' it with a black cat on a leash (see p. 116, left). Another model sported a second-skin dress topped with a latex-rubber coat (see p. 117, bottom right). Much was made of Gaultier's use of plastic and stretch materials, which allowed for tight fits. He had become a designer to reckon with. The *Los Angeles Times* reported that 'a survey published this week in the French *Journal du Textile* ranks him as the bestselling designer in European boutiques'.

Still, he wasn't outside of the trends. The lingerie theme was prevalent in Paris for Spring/Summer 1987. And at the same time that Christian Lacroix's name (he was then at Patou) was becoming synonymous with pouf skirts, Gaultier was adding them to the end of trapeze dresses. This silhouette alternated with empire lines and midriff-baring looks. Sarah Mower, writing for *The Guardian*, concluded: 'Gaultier's collection now is a fascinating melting pot of fashion influences.' He was one designer who could never be accused of lacking personality.

Forbidden Gaultier

Editors and guests who once again headed back to the Grande Halle de La Villette for Jean Paul Gaultier's Autumn/Winter 1987–1988 show were kept waiting in the cold for a long time. Once inside, the *International Herald Tribune*'s critic Hebe Dorsey accused the designer of keeping his audience in the dark – and worse. (This, despite shoes designed with clear heels and containing light bulbs that flashed as the models walked.) 'Gaultier's mild jokes have soured,' she wrote, criticizing his 'deliberately vulgar Happy Hooker look and sex-shop approach'.

The designer did make liberal use of latex. He also showed metal corsets (see p. 121) as well as 'rubber breasts with nipples' and 'antennae', as the *Fort Worth Star-Telegram* reported, yet this collection was less about sex than another S-word: space. An Associated Press reporter quipped that the 'clothes were based on intergalactic nonsense and spaced-out "Star Wars" – with a peeping-Tom's look at the underwear in grandma's closet'. The idea, it seems, was to design clothes for four imaginary planets, with names like Patch, Demode Space Age and Obsolete Futurism. One has to wonder if this intergalactic excursion, in which some models wore space helmets or plexiglass orbs, was somehow a reference to Gaultier's early years working with Pierre Cardin, one of the preeminent Space Age designers, who would later acquire the Palais Bulles or Bubble Palace.

In hourglass jackets – some in denim, others with foam-padded hips – there were also seemingly references to Christian Dior, creator of the 'New Look', whose work was then on display at the Musée des Arts de la Mode in Paris. Fairchild News Syndicate's description of the lineup having a 'back-to-the-future' aspect rings true for the pieces with feather and puffed sleeves. But it was the way that Gaultier made hybrids, like Aran-knit sleeves attached to a latex body, that caught the attention of other contemporary viewers and might be seen as a manifestation of a philosophy. As Michael Gross, writing for *The New York Times*, observed, 'The attraction was Gaultier's post-modern mix. He plunders the past and the world around him.' Not to mention the galaxies.

The Concierge is in the Staircase

The concierge is a stock figure in French culture and literature. A charwoman/informant (the job is held mostly by women) may be low in status but she is rich in knowledge, keeping track of the comings and goings of the inhabitants in an apartment building. She was the nominal heroine of Jean Paul Gaultier's breakthrough collection for Spring/Summer 1988.

'Gaultier's collection was a brilliant confirmation of his unmatched natural gift for streetwise charm, wit and humor. Like [Christian] Lacroix's homage to Arles, Gaultier returned to his roots – the back streets of Paris, its colorful characters and romantic history – for inspiration,' wrote the *Toronto Star*. The show, the reporter continued, 'opened with an accordion-playing performance that evoked the spirit of gay Paree and ended with a hilarious cleaning lady's monologue in French'. Indeed this show, a celebration of French style, had a homecoming feeling. It was there literally in the references to interiors (lace curtains and floral chintz). But there was also a feeling that the designer put gimmicks aside and abandoned himself to the joy of design.

The beauty of the clothes is seductive, particularly the louche drape of the tailoring: 'It's been too long since we've seen long, loose pants, and I think women want them,' Gaultier told *WWD*. Contemporary viewers made much of the scarf-tied off-the-shoulder looks and leotard-jacket hybrids (see p. 127, bottom right). The combination of apron over pinstripe suit (see p. 126, bottom left) was an exemplary instance of the masculine/feminine theme at the centre of this designer's work.

Gaultier continued with the hourglass shapes of the preceding season (see p. 118), and there were the requisite lingerie looks, but they were less strident. In fact, there was a series of petalled romantic looks, the most extreme of which was a white skirted gown in which the cone breasts served as beehives as they became a resting place for insects (see p. 131, bottom left).

The clarity, beauty and confidence of this lineup earned Gaultier the French fashion 'Oscar' for best collection. He thanked Pierre Cardin, his first employer, and his role models, André Courrèges and Yves Saint Laurent, in an acceptance speech at a ceremony that effectively placed Gaultier – a designer who venerated French fashion while moving it forward – among their ranks.

Boarding Schools

'The cone-bosomed, spike-heeled mannequins have been replaced by pigtailed schoolgirls wearing pompo[m] knit bonnets. But these collegiennes have a touch of the tomboy,' noted *WWD* of Jean Paul Gaultier's Autumn/Winter 1988–1989 outing, which built on his triumphant Spring/Summer outing (see p. 124), both materially and in tone. For example, the designer carried on with the off-the-shoulder look, adding cuffs of fur to the top of empire jersey column dresses that had a vaguely medieval air (see p. 137, bottom right). Jacket-bodysuit hybrids were back, too, one in red worn dramatically over full grey pants (see p. 135, left). Military touches and harlequin patterns were pulled from some of his earliest designs, while vaguely ethnic patchwork knits with metal embellishments hinted at the melting-pot direction Gaultier would increasingly explore.

Though it was less outré than some other shows, Gaultier certainly wasn't treading water; in fact, the feeling of movement was underscored by his use of a moving sidewalk (of the sort you see in airports) on the runway. In addition, the offering, which included stirrup pants and nylon cape-jackets, was extremely wearable. As *WWD* noted, 'Gaultier infuses new life into wardrobe staples, and his updated renditions of classics are a delightful surprise'… and conducive for getting on with one's life. Adding some vintage charm were capes and hat pins. Charm also came in the form of those pompom beanies. Playing off the school theme (models wore their hair in plaits, and some carried book satchels), you might say the collection was a lesson in modern style.

Around the World in 168 Outfits

The invitation to this show featured a headdress-wearing, nose-ringed model, with her head thrown back, cigarette in mouth, against a painted background that seemed to evoke Gustav Klimt's gold paintings. The title suggested a cross-cultural mix, and there was a good deal of that, but in the end this unresolved collection seemed to be a tour of Jean Paul Gaultier's world more than anything else.

'Confusion Reigns' read the headline of an article that summarized the season, but which could also be applied to Gaultier's show during which models walked a triangular runway. The hairstyles and footwear provide the clues to the collection's various sections. High red platform shoes seemed to correspond with a pan-Asian segment that included tunics over pants; while thick-soled espadrilles accessorized more nautical looks, some traditional and others more outlandish, like a Breton top under a mesh fishnet dress (see p. 140, bottom right). There were printed looks with vaguely peasant origins. Lingerie chaps, inspired by Spanish gauchos, were among the garments that led one reviewer to describe the look as 'part cowboy, part Texan whorehouse, with frilly bloomers and pink satin bodices cavorting with strict, tailored jackets and bullet belts which were loaded with lipstick' (see p. 141, top left).

Some of the suiting ensembles were gussied up with multiple pairs of suspenders (see opposite, bottom right). Most shocking to the contemporary press were the low-waisted coloured denim pants worn over matching high-cut bodysuits, which bared the hip (and which presaged the thong-strap-baring looks of the following decade) (see p. 140, left). Also skin-baring were looks that seemed based on cage crinolines, though a reporter for *The Sydney Morning Herald* suggested Gaultier had stripped his beloved corset 'down to a carcass of bones, leaving the flesh bare beneath'. In any case, the geometries of these looks (see pp. 142–43) complemented those of the headpieces.

This wasn't a 'tight' show with a well-defined message, but as journalist Robin Abcarian noted, 'It's hard to fault Gaultier for off-the-wall ideas. His outlandish clothes have had a pervasive influence on the world of ready-to-wear fashion.' Abcarian also related the following: 'Watching Dianne Brill bend over to shake her bosom at Jack Nicholson, who was sitting in the front row, then tip herself off the runway was worth the price of admission.'

Women Among Women

The Washington Post's Nina Hyde reminded readers that the Autumn/Winter 1989–1990 season in Paris had a greater significance than usual, writing: 'As designers here present the clothes they expect women to wear in the 1990s, they're also expressing their views of the role of women and of how women will want to posture and present themselves in the next decade. It's a varied and sometimes scary view,' she concluded. Not least *chez* Gaultier, where some models were strapped into headpieces inspired by an advert for an anti-wrinkle contraption of the 1930s, intended to be worn while asleep to prevent facial lines (see right).

The title of the collection, 'Women Among Women', is perhaps ironic, as there was little overtly feminine about the offering, to the point where one wondered if Gaultier imagined women alone as men. At some moments the runway looked like it had been overtaken by a convention of dominatrixes in zip-seamed get-ups with holes cut out at the breast and buttocks (see p. 149, right); at others, it seemed patrolled by British grenadiers in bearskin hats (see opposite, top right); and then there was a gaggle of dandies in frock coats and vests (a character Romeo Gigli was also taking up) with top hats bound to their heads that charmed the crowd and editors, too. (One of these looks – see opposite, bottom right – was photographed by Irving Penn for the August 1989 issue of American *Vogue*.)

This show presented tartans and sex-shop references; the cage shape of Spring/Summer (see p. 138) returned, this time in knit form (see p. 146, bottom left); and pleated skirts were worn over pants – those with suspenders called to mind an American *enfant terrible*, Eloise at the Plaza. There were nods to the 1940s in turbans, and New Wave references in angular bangs attached to headbands. Yet it seems the interwar era was the starting point for this collection. 'The show itself was pure theatre ... based on Christopher Isherwood's Berlin of the 30s, and its sinister overtones, complete with army helmets, clomping boots, S and M outfits, bondage and a male fashion editor, Hamish Bowles of *Harpers' & Queen*, masquerading as a model' (see p. 147, top right), reported Ann Chubb for *Wales on Sunday*. (In a recollection of that experience for Vogue.com, Bowles remembered being told by Lionel Vermeil, then head of public relations, that Gaultier had been inspired by 'Weimar-era lesbians'.) Thinking more broadly, perhaps the designer, looking back at history, saw that power was associated with masculinity and wanted to transfer some of that influence to women through sartorial plays on gender.

Rap'Sisters

Jean Paul Gaultier closed out the 1980s
with a dramatic – and controversial –
presentation in which he revisited a good
number of themes he had been playing with
for more than a decade. The main message
was shorts: some worn over chiffon pants,
others over pinstriped ones. There were
also many shorts-length bodysuits; and
the further integration of active sports into
ready-to-wear (see the hoodies worn with
suits; p. 152, bottom left) was one of the
key takeaways.

There were many desirable pieces, but
it was the presentation – which might
be described as nuns meet sports, sex
and Constructivism – that captured the
imagination at first. The show opened with
models carrying urns of burning incense
through the vast space of the Grande Halle
de La Villette. Abandoning the catwalk, the
designer had built a platform in which circles
were cut, through which models ascended
and descended ('to fashion hell', one
journalist quipped) on spin-me-right-round
rotating platforms. The first group of models
wore nuns' coifs and appeared to strains
of *Kyrie*, part of the Christian liturgy; what
sounded like Islamic chants were mixed
in subsequently, and some of the later
headdresses bore a resemblance to hijabs.

Titled in French 'Les Rap'pieuses' – a
portmanteau, it seems, of '*les rappeuses*'
('the female rappers') and '*pieuses*' ('pious',
in the feminine) – the show appeared seven
months after Madonna released 'Like a Prayer'
(and pre-dated her history-making, Gaultier-
costumed *Blond Ambition* tour by six months).
Yet the star of this presentation was Neneh
Cherry (see p. 155, left), who released her
debut album *Raw Like Sushi* in 1989. 'She
will be the Madonna of the '90s, but far
less aggressive,' Philippe Krootchey, one
of Gaultier's music collaborators, told
The Washington Post.

Although *The San Francisco Examiner*
ran a headline that read 'Shaking up Paris:
Jean Paul Gaultier's naughty nuns cause
the biggest rumble', this was a relatively tame
show – despite the quip of one photographer,
who said, 'It's not so much ready-to-wear
as ready-to-unwear.' *Press of Atlantic City*
noted: 'Gaultier's focus on underwear has
softened. The pointy stitch bras are gone and
now he offers his variation on old-fashioned
corselets, as well as bra construction stitched
into slips and underwear showing through
sequined layers.' This is hardly a shocker
at a Gaultier show.

The conclusion, featuring Constructivist-
style ensembles (many with back-lacing
details; see pp. 154–55) inspired by the work
of the German-born painter Richard Lindner,
suggests that Gaultier continued to worship
at the altar of art.

Memories of Buried Pasts, as Time Goes By

The shock value of this Jean Paul Gaultier outing was that it made use of the traditional runway format. In the intimate, draped setting of the Espace Elysée – 'a trendy club decorated like a bordello', the *Detroit Free Press* reported – there were 'detailed programs on the seats and waiters serving champagne, prompting one fashion editor to wonder aloud if she had come to the right show'. The soundtrack was provided, live, by the accordionist Yvette Horner.

Gaultier put aside his usual antics to focus on many classic pieces, such as duffle coats and parkas, and Aran and Fair Isle knits, which he layered and played with, as is his wont. Though the mixes were eccentric – a semi-sheer sequinned dress doesn't really 'belong' over a woollen bodysuit (see p. 159, left) – each piece was desirable in itself. (Fans of Martin Margiela, who had trained with Gaultier, might notice the fur-print linings of some of the coats; see p. 158, right.) There was also a strong element of dandyism to which patterned knits and boots added an Alpine accent, and braids and headscarves added a bohemian touch.

The designer's stated inspiration was 'White Russian aristocrats mixing with the French working class after the revolution'. This gives context to the layering aspect of the clothes. 'His refugee ensembles recalled history book accounts of Poles, Russians and Czechs fleeing home... taking only what they could carry,' wrote the *Los Angeles Times*. 'These clothes told far more than just fashion stories about fabric mixes or day-into-evening dressing. They spoke about a moment in history that Gaultier obviously finds moving.' (Indeed, the influx of White Russians had a great impact on Parisian fashion, with many down-at-heel aristocrats employed by designers including Gabrielle Chanel, who also took the Grand Duke Dmitri Pavlovich as her lover.) Embroidered and cropped torero jackets (see p. 159, bottom right) shared space in this lineup with a stately-looking suit featuring Russian-style passementerie. It was one of three 'party in the back' ensembles in the show, as it was slit open to reveal the skin and the buttocks (see p. 161, top right): possibly a sort of commentary on the concept of 'saving face'.

Two last takeaways: the designer's models, suggested *The San Francisco Examiner*, were chosen 'to show that many different ages can wear his clothes'. Also of note were the 18th-century-style wigs (one of which lit up like a lamp; see p. 161, bottom right) made of ribbons. Some of these seemed to relate directly to Marie Antoinette, who also arrived in France from afar, and whose name is forever tied to another revolution.

The Couple – Adam and Eve, Today's Rastas

Around the same time that Jean Paul Gaultier was publicly celebrating couplehood, he had tragically lost his beloved partner, Francis Menuge, to AIDS. There were no signs of his personal loss in this show, the invitation of which featured a latter-day Adam and Eve in Eden. Despite the rise of the far right, and an atmosphere of what Gaultier dubbed a 'new Puritanism' in an interview with *The Guardian*, he didn't hesitate to show love in many forms: same-sex and mixed-race couples walked the runway, and there was PDA, too, in the form of smooches, and one female model grabbed the bottom of her male escort.

The designer's only bow to convention was to have his couples – whom the collection title described as 'today's rastas' – wear matching, or complementing, outfits. 'A kind of stay-loose, cross-dressing atmosphere prevailed,' noted the Associated Press, while *The New York Times* made note of a new gentleness, writing that 'there was real excitement in the clothes, which were a departure from the Gaultier collections that broke clothes down to their underpinnings and always seemed to hint darkly at bondage. This collection was rosy and cheerful, a loving statement about the possibilities of dressing. The models reflected the new softening.' Yes, there was a fairly stiff pair of matador jackets made up in clear plastic (see opposite, top left), but pinstriped suits were shown with wrap-shorts (see opposite, right), and Gaultier made use of drawstrings to create adjustable clothes with a curtain effect (see right). Of note was his tulle-skirt overalls combo (see p. 165, left), a variation on his moto/tutu signature ensemble.

On a side note, Rossy de Palma, the Spanish actress (see p. 164, left), was in the cast of models, as was the American model Tony Ward (see p. 164, left, next to de Palma), then Madonna's paramour, who, during the show, presented her with a doll dressed in a miniature version of one of the costumes Gaultier had designed for the artist's *Blond Ambition* tour.

French Can-Can

Both Jean Paul Gaultier and makeup artist Stéphane Marais won Venus de La Mode Awards for the 'French Can-Can' show of 1991. The collection was, noted the *Chicago Tribune*, a homage to the Moulin Rouge of a long-ago past. Marais's makeup look was called 'La Goulue' after the celebrated cabaret dancer and muse of artist Henri de Toulouse-Lautrec.

There was a green-lined can-can skirt (see p. 171, left), and Gaultier joined in the leg-lifting dance at the finale, but overall this outing might be described as a mixed metaphor. The location was actually a circus building (Cirque d'Hiver), with 'a tacky showbiz charm ... the perfect setting for designer Gaultier's spoof of formal fashion shows', according to the *Montreal Gazette*. On top of that, the designer had the floor laid with synthetic ice, so a pair of figure skaters could perform during the show, and there was once again some accordion music. The clothes were similarly antic, with fur-trimmed pieces introducing the idea of winter, and models in streamlined bodysuits with built-in boots, and in one case a face cover (see p. 169). (This idea of using a bodysuit as a base to be layered upon can be traced back to the Space Age '60s, and particularly to Pierre Cardin and André Courrèges; Gaultier would build an entire couture collection around it in 2003, see p. 358.)

Camp touches abounded, like the towering feathered headdresses worn by male models, and a headband made of lipsticks. There were vaguely S&M dog collars from which a long chain holding a coin purse was connected. In one instance, two models came out together: one walked ahead with the front of a nude body painted onto the front of her pantsuit, while the one following had the back of a nude body painted on hers (see p. 168).

More relatable were parkas with tufting details, square pattern pieces that created handkerchief hems, and built-out hips. Reviewers made note of Gaultier's use of longer skirts, as well as convertible clothing. Tanel Bedrossiantz – a Gaultier muse – unzipped a black nylon bomber to reveal its tan marabou lining. Another model came out in a skirt suit with what looked like a red cardigan over it, then she let it fall to become a train; similarly, a white coat with double rows of black buttons was transformed into a bolero (see p. 170, left and bottom right). (On the 30th anniversary of the house in 2006, Gaultier, playing a magician, would pretend to saw an editor in half, using a related type of legerdemain.) In the end, it seems like there was more 'can-do' attitude in this collection than actual 'can-can'.

amfAR Benefit, September 1992

'Unforgettable' is the only way to describe the 1992 amfAR benefit hosted by Herb Ritts and Madonna at the Shrine Auditorium in Los Angeles. The draw? A runway sensation that featured looks from Jean Paul Gaultier's catwalk career to that point, presented by models, muses and megawatt celebrities.

Gaultier's runway shows were always rich in spectacle, but – barring his goodbye extravaganza – none came close to rivalling this to-do, which also featured performances by Patti LaBelle and Luther Vandross, as well as high jinx by the Red Hot Chili Peppers (see p. 188, bottom). Sexpert Dr Ruth Westheimer walked the runway in a rubber nurse's uniform (see p. 188, top left). Jennifer Flavin, Raquel Welch (see p. 188, top right) and Lady Miss Kier were also spotted on the runway. After squiring actors Faye Dunaway and

Lorraine Bracco onto the stage, a shirtless Billy Idol (see p. 189) mooned the paparazzi. But that was just an appetizer. It was Madonna who brought down the house by deciding to wear a suspendered Empire look (see opposite, bottom right) from the Autumn/Winter 1992–1993 collection (see p. 176), sans pasties.

Financially successful, the event raised about $700,000 for the American Foundation for AIDS Research at a time when the disease was ravaging the gay community and the fashion industry. It had killed Gaultier's partner Francis Menuge in 1990. Still, the designer soldiered on, advocating for condom use and declaring: 'I think fashion can make people think… and what will be important in the '90s will be to wake up and look at what is happening in the world.'

Chic Rabbis

When Jean Paul Gaultier explored the boundary between the sacred and the profane with his 'naughty nuns' of Spring/ Summer 1990 (see p. 150), there were few repercussions. Reactions to his 'Chic Rabbis' collection of Autumn/Winter 1993–1994 were far more divided, with some wondering if the intent had been paean or parody.

In a 2023 *Vogue* interview, Gaultier said the idea for the collection 'came to me when I visited the Jewish quarter in London, and I was struck by this community and the power of the way they dress'. He invited his guests to the intimate confines of Galerie Vivienne, adjacent to the *maison*. Upon arrival they were served glasses of Manischewitz wine. The mood lighting was provided by electric menorahs (which aggravated the photographers no end). 'Hava Nagila' was blasted from a boom box, and a violinist walked the runway playing music from *Fiddler on the Roof*.

Gaultier fashioned himself a Breton-stripe yarmulke to match his top. He flipped his skirt up at the end of the show; and he also flipped the script, according to a Gannett News Service report that said the designer 'had the models walk an oval that took them outside the gallery briefly. Thus, the fashion groupies on the sidewalk got a peek, and Gaultier took a giant step toward liberating the Paris shows from their snobbish exclusivity.'

Gender play is one of Gaultier's design commandments, but some took issue with him using rabbinical dress for co-ed garments. Fashion-wise, the collection saw the Frenchman continue to explore an Empire silhouette for Fall, showing his signature high-waisted suspendered pants again, as well as boleros. Mixed in among the clip-on sidelocks and platter hats were many elements of punk (tartans, bondage straps, harnesses, ripped stockings and DIY jewelry), as well as (artful) deconstructed tailoring. 'Jean Paul Gaultier: Devoutly Irreverent' was the title of the caption that ran with Steven Meisel's photograph of the collection for American *Vogue*.

In a post-show interview, Gaultier opined that, in the face of increasing racism and anti-semitism in Europe, 'it was the right moment to show that and to take a position'. Some twenty years later he said: 'I was afraid that the collection would be poorly received. I knew reactions might be mixed. What I wanted to convey with this collection was the feeling these traditional costumes gave me, to pay tribute to their beauty.'

The Great Journey

Having received an invitation in the form
of a ticket for the 'Trans-Occidental Orient-
Express', guests gathered at a specified
Metro station where they were transported
to another world. In a building housing
decommissioned train cars, 'snow' had been
sprinkled on the path the models' journey
would take, which would be recorded not just
by the usual corps of photographers but also
by director Robert Altman, who was filming
Prêt-à-Porter.

As is often the case, fact beat out fiction.
The 'snow', reported Robin Givhan, was
rumoured to be 'Styrofoam soaked in
formaldehyde' and was giving off noxious
fumes, and the designer gleefully made loose
and free with geography, casting the Icelandic
singer Björk (see right) in a show that was
otherwise inspired by Outer Mongolia and the
Inuits. (This show pre-dated Isaac Mizrahi's
'Nanook of the North' collection, as shown
in the documentary *Unzipped*.) 'Gaultier is
not the first designer to be inspired by Inuit
costume, but he is the first internationally
known one to take the folklore imagery out of
it – and to mix it with other pieces of clothing,'
noted the *Montreal Gazette*. 'Until recently,
the biggest changes in the Inuit parka have
been in its decoration ... but until Gaultier, no
one has ever given it the glamor treatment.
He takes it for granted there are many
standards of beauty in the world and
loves to mix them all.'

The 'hero' piece of the lineup was a logoed
shearling anorak. Also delivering warmth were
giant hoods, quilted robe coats, and a puffa
in patterned silks (see p. 210, left). A velvet
tunic had a cheongsam-like asymmetric
closing (see p. 211, left); frog closures and
tasselled belts were prevalent. As for motifs,
there was a jacquard in an astronomical
theme and many dragons, some printed
on sheer mesh, which also featured a motif
that resembled currency.

A deconstructed pinstriped jacket had pattern
pieces laid atop a lighter-weight printed fabric
(see p. 208, right). Such layering created a
nomadic vibe, though super-high platform
shoes seemed impractical for hoofing through
the snow. Silver jewelry borrowed motifs from
bikers and other cultures. Models wore their
hair in plaits, and some had tiaras; others
had coifs with candles (see p. 210, top right) –
a reference perhaps to the Swedish Santa
Lucia tradition.

Fin de Siècle

Fashion time can be more interpretive
than precise, as Jean Paul Gaultier's
Spring/Summer 1995 show demonstrates.
At a time when many were looking ahead to
a new century, the designer's extroverted
joie de vivre felt out of sync with this
'repentant' vibe, a shift in mood after the
Greed Decade. After the death of his great
love Francis Menuge, *The Observer* reported,
'it took the designer a good deal of time
to pick himself up and to push on again'.
He emerged a revitalized force: *The Face*
magazine talked pointedly of 'the Gaultier
renaissance'.

Now, on the 'Fin de Siècle' catwalk, Gaultier
showcased looks that represented the
century. Though he threw in an Eve in fig
leaves and a see-through dress, the theme
of the show was a decade-by-decade look
at 20th-century fashion history, from the
Belle Époque, the era brought to a close by
the First World War; to 1947, and the moment
referenced by Christian Dior in his 'New Look'
collection, which set the tone for post-
Second World War fashion; and on to the
1970s. Tearsheets from fashion magazines
were collaged into a print used on modern
mesh separates. Pantaloons and corsets, like
those depicted by Manet in his 1877 painting
Nana, came from another age. Sometimes
pieces from different eras were combined;
in other instances, fabric choices – say,
denim for a corset – might be used to
change things up.

Actress and model Isabella Rossellini
appeared as herself while Anna Pawlowski
in a big hat and wide pants (see opposite,
top right) conjured up Renée Perle, the
epitome of 1930s elegance and the muse
of photographer Jacques-Henri Lartigue.
Madonna, soon to enter her Evita era, closed
the show pushing a white puppy in a vintage
pram and wearing a spangled look that also
referenced that decade (see p. 215). War
rationing meant short dresses in the early
'40s, and these, accessorized with platform
shoes, were sent down the runway on both
women and men alike. On the latter they
looked more like a reference to Kurt Cobain,
who performed in a frock in 1993, than to
fashion history.

'Fashion is magic,' exclaimed Gaultier,
speaking to CNN from a red-lined magic
box that revealed only his head. He said
he wanted to kickstart 'the comeback of
elegance because now we are in a world
where there are some problems. It's nice
to see some women who want to look...
very elegant and chic.' The method to his
madness was mixing looks together, like
'a dadaist collage that makes something
like a new silhouette'.

The Amazons

Jean Paul Gaultier continued to explore ideas around time for his 'Amazons' show of 1995, in which armour and historical silhouettes were reconceived within the framework of a dystopian future time. The designer was working on costumes for *The Fifth Element* at the time and he admitted that this influenced the collection, saying, 'It's not *The Fifth Element*, but I was into that spirit.'

The collection was popularly dubbed 'Mad Max', but the designer, in a backstage interview with journalist Tim Blanks, said that 'Mad Maxette' would be a more accurate description for an offering that celebrated women's strength. (Two pregnant models walked the runway.)

The show opened with a leather-clad woman driving a roaring motorcycle onto the scaffolding-surrounded runway. How that related to model Carmen Dell'Orefice carrying a hawk (see opposite, top left) is not crystal clear but seemed to have some reference to battle. Some armour-like overvests had embellishments that referenced computer imagery (see opposite, bottom left), and other looks were made using quilting in a computer chip pattern (see p. 220, bottom left). Some male models wore masks with lips where the mouth would be (see opposite, bottom right). Further contributing to the sense of comic-book adventure was a 'Virus Man' cartoon print, though with a serious message about AIDS. Colourful squares were painted over one eye of the models by makeup artist Topolino. 'I wanted something like... digital makeup, blue makeup and pink hair. Punky, let's say. Even the hair was between the dreadlocks and the Marie Antoinette. It's a mix of time,' Gaultier later told *Vogue*.

The show closed with a campy end-up, or rather blow-up, of historical silhouettes made using padded fabrics, which gave them exaggerated proportions. In several cases, models carried hairdryers that inflated their looks further (see p. 221). This 'technology', which referenced Gaultier's grandmother's old beauty tools, seems primitive in contrast to the designer's use of a 'techno' fabric like neoprene. The dot bodysuit – very Vasarely-meets-cyborg (the designer said he had been thinking about the work of the Op Art artist) – debuted in this cyberpunk collection (see pp. 218–19) and it has since achieved cult status, going on to be reissued by the house in the 2020s.

Cyberhippie

Viewed through a 2020s lens, Jean Paul Gaultier's 'Cyberhippie' collection reads as appropriative. At the time, however, this show, whose heroes and heroines seemed to be world-travelling space cowboys, was seen as another of the designer's Mad Mix (rather than Max) extravaganzas. *The Birmingham Post* reported on the oddball accessories, which included 'Phylactery cigarette holders, Japanese wooden clogs on two-inch cleats and electrodes glued to the temple'. The *Evening Standard* declared: 'Here were the united colours of Gaultier – the Wild West, Tex Mex, Africa, India, and New Zealand.' Western looks featured laser-cut leathers; printed mesh pieces referenced Maori *ta moko* tattooing; and the designer's forays into Africa included the use of elephant, lion and flamingo photo prints and beading.

Writing for the *Philadelphia Inquirer*, Roy H. Campbell said: 'Gaultier made cultural icons of the ceremonial robes and other dress of the African nations. And in further homage to people of color, Gaultier twisted most of the models' hair into the dreadlocks that are de rigueur among members of Jamaica's Rastafarian religious sect. He also did his bit for integration, stirring the influence of African dress into a melting pot and coming up with dashikis over cowboy pants and worn with Japanese sandals.' At the same time, model Chrystèle Saint Louis Augustin walked the runway in a blazer, white polo and rolled-waist khakis that would have suited actress Katharine Hepburn.

A journalists' mantra when it came to Gaultier was that his showmanship camouflaged the real- and retail-world appeal of the clothes. For many, the designer's refusal to compromise his vision for stores, or in the face of danger (there had been a number of bombings in Paris, and the mood at the shows was sombre), was heartening. 'The denizens of the underground have a true deity in Jean Paul Gaultier. In spite of his success, he didn't sell out,' Campbell wrote. 'Gaultier is still anti-establishment.' He was also in some ways an activist. This collection included a print that read 'Safe Sex Forever'.

Building on his past successes, Gaultier revived his short pants of 'Les Rap'Sisters' (see p. 150) and collaged his popular print meshes in clashing patterns. Expanding on his Vasarely body-prints from the previous season (see p. 216), he achieved the same effect using lines and Ben Day dots (see p. 224, bottom left); in some cases, female models wore male bodies (see p. 224, right).

Sphere and Cube

In some ways, Jean Paul Gaultier's 'Sphere and Cube' collection was a technical self-challenge in construction. The idea seems to have been to play with two basic building blocks to Modernist and sometimes Cubist effect: 'His pants had square legs seamed in four places to form "corners",' reported *Newsday*. 'His leather bustier jumpsuits and color-blocked vinyl dresses were made like boxes, but still looked supple and even figure-enhancing. To complete the look, the heels of Gaultier's shoes were leather-covered cubes. Spheres came to Gaultier's party too.' In one instance, Helena Christensen, lying naked on a pink faux-fur-covered bed, pulled on a two-seamed red velvet slip dress from which extended two long straps, strung at the end with heavy metal balls: it was their suspended weight that kept the dress on and in place (see opposite, top right).

As usual, Gaultier took the theme and ran with it: 'Guests sat on white styrofoam cubes. Many of the garments were constructed from squares and rectangles of fabric. The models' hair was pulled up into cube-shaped top-knots. Videos were shown on a square screen,' reported the *Detroit Free Press*. 'Strapless dresses stitched from rectangular panels looked sleek and fit well. Belted jackets constructed from the same rectangles looked smart over slim pants.' One of the effects of all this geometry was to evoke the spirit of the '60s. There were references to the work of Pierre Cardin, Gaultier's mentor, and a spoof of photographer William Klein's 1966 fashion film parody, *Who Are You, Polly Maggoo?* (see also p. 604). Models vamped, and Tanel Bedrossiantz, dressed like Steven Meisel, played the part of the photographer, perhaps referencing Michelangelo Antonioni's 1966 fashion thriller, *Blow-Up*. Pure Gaultier touches were the 'sex-shop' latex cut into cheongsams (see opposite, bottom right), and in some cases layered over tulle ball skirts, and the Op 'Spirograph' print of coiled spheres (see right and opposite, bottom left).

Punk Parisienne

Jean Paul Gaultier continued to play with construction for Spring/Summer 1997. For Autumn/Winter (see p. 228) he had put it to use, in part, for functionality, as in a slip dress that stayed on the body by the use of weights attached to straps. For Spring/Summer he used the make of the clothes to amaze the eye, showing a collection full of zip- or tie-back jumpsuits that resembled three-piece suits, often with bra/bikini tops underneath. Stockings and underwear deliberately peeked out over waistlines.

The show, reported the *Los Angeles Times*, 'was held at a sleazy old theater in the city's red light district' – a stand-in, perhaps, for the docks cruised by the lustful sailors (à la *Querelle*) who are such an integral part of Gaultier's iconography. Men and women in naval looks walked the runway, as did a few hippies (see the designer's use of tie-dye, scarf-tied hair, and clusters of badge-pins accessorizing mesh shirts, plus a few more raunchy characters who really pushed the limits of taste wearing fishnets with brief-sized shorts). Other models wore thongs over hose, at a time when these weren't common. Perhaps it was Alexander McQueen's bumsters of Autumn 1995 that started drawing attention to back views, although Gaultier always designed in the round.

Choosing to follow the couture custom of closing with a bride, Gaultier sent Nikki Uberti down the runway in a short-sleeved, tent-shaped white rose jacquard dress. When she turned, the dress was open in the back from neck to toe, revealing black fishnets worn under a white thong in which white lilies had been positioned (see p. 233, bottom right). The model proceeded to 'moon' the audience, which truly shocked many who were present.

Other models in similarly cut looks wore men's ties down their backs, and there were other examples of trompe-l'oeil prints, including a pair of unzipped jeans (see p. 233, top right). This 'party in the back' collection was, in some ways, a study on reversal – both in the back-front dichotomies and the eye-teasing conceits and, more generally, a reversal of expectations, which is one aspect of the designer's m.o. You don't always get what you see. Appropriately, the soundtrack to the show, reported *The Toronto Star*, was 'every imaginable version of "My Way"'.

Haute Couture
Salon Atmosphere

A new chapter opened for Jean Paul Gaultier with the snip of scissors through a semi-transparent scrim in a room filled with rows of gold chairs and anticipation. Wielding those scissors was a flame-haired model who opened the designer's debut couture collection.

Gaultier took on the highest expression of his *métier* in a trickle-up manner, using elements from his prêt-à-porter in his couture designs. In so doing he expanded what this genre of fashion could be. Alongside more luxurious materials, he used denim, upcycling his own old pairs, which were ornamented by Lesage with 18th-century and Belle Époque motifs (see pp. 236–37). 'It's the first time they bead on denim,' Gaultier told *The Sunday Telegraph*.

Most daringly, *Vogue* noted, 'Gaultier has done unisex couture, which is probably the newest take on the old métier yet.' All genders wore lace, as eyebrows, beards and hair, as well as on their bodies. One of Tanel Bedrossiantz's exits was a black jumpsuit with a lace inset that extended to a button featuring the Eiffel Tower (see opposite, top right; echoing a look in the 'Fin de Siècle' collection, see p. 212). A sheer chiffon top featured an embroidered 'label' complete with four 'stitches' (see p. 238, bottom right). This thread quartet had become Martin Margiela's logo of sorts, possibly predicated on Gaultier's signature hanging loop. Margiela was front-row to support his mentor, as was Yohji Yamamoto.

There were nods to the golden age of couture and to Yves Saint Laurent, as well as many Gaultier-isms, including a Breton-striped gown of lace (see opposite, left), and a beaded flapper dress that folded into a pouch that the model then strapped on like a mini cocktail apron (see opposite, bottom right). There were corsets and traditional pinstriped suits, and a pinstripe made of sparkling beads. There was an evening look with rainbow feathers (see p. 239), and Kristen McMenamy wore two of the most stunning designs: a dragon-embroidered corset with a draped red skirt (see p. 238, left), and a 'cloud' dress of airiest white and mocha tulle (p. 238, top right).

This was a big season for debuts, with John Galliano starting at Christian Dior and Alexander McQueen at Givenchy (a job for which Gaultier had been recruited). Unlike those Englishmen abroad, Gaultier was not out to destroy what had come before so as to leave a mark, but to elevate and evolve. 'Instead of a birthday cake, I am doing a couture collection to celebrate 20 years in the business,' he stated. *New York Times* critic Amy M. Spindler commented: 'Fashion has long been spoiled by Mr. Gaultier, whose every show is nearly couture quality.'

Black Culture and Black Power

Jean Paul Gaultier's Harlem-inspired collection for Autumn/Winter 1997–1998 was greeted with raves. 'Gaultier pays cultural homage with respect: Designer goes African American without stereotyping', read one headline. 'The collection was hip-hop deluxe, Harlem cool, urban African, diva fabulous and bluesy smooth,' wrote *Washington Post* critic Robin Givhan.

Why did this collection succeed? Maybe it had something to do with the clothes enhancing the women who wore them, and not the other way around. On an elevated platform in the shape of a boxing ring, the models appeared as conquerors, sure of themselves and their beauty. Gaultier's casts were always diverse, in many ways; this season, all but one of the models was Black, which was, *The Guardian* reported, 'a protest, it emerged later, against the French government's tightening of immigration laws'. (Kristen McMenamy was the only white model.) The casting, Givhan noted, was especially resonant 'after fall '96, when models of color were virtually absent from the catwalks'.

This was a purposeful collection, then, and most of the looks could have walked off the runway and into real life with little to no alteration. Strong-shouldered, masculine-style suiting was key here, with braggadocio 1970s-style pinstripes sharing space with the oversize Zoot suits associated with the Hepcats, i.e. fans of jazz and blues music of the '40s. Flapper dresses referenced Josephine Baker and the Harlem Renaissance. Peacoats and other collegiate staples mingled with athletic gear, and garments – such as 'beautiful, narrow, hooded cashmere sweaters [that] were descended from a rapper's sweatshirt' (see p. 244, left), called out by the *Los Angeles Times* – referenced hip-hop style.

Gaultier approached these varied inspirations with a seriousness, and refrained from his usual theatrics, allowing the models and the clothes to hold their own. 'Gaultier's provocative message', wrote Amy M. Spindler, 'was a reminder that those periods were not only influential on fashion, but were deeply sophisticated.'

Russia

This season, Jean Paul Gaultier was spinning tales about an imaginary czarist Russia, while, for good measure, adding a few Spanish-style accents. Models with what the Associated Press described as 'Catherine the Great' braided coifs walked to the sounds of violins and balalaikas in clothes that spoke of splendour and warmth. Fur, shearling and feathers added texture to coats. Robe-style toppers seemed to acknowledge Russia's border with Mongolia, while others appeared to nod to Yves Saint Laurent's famed Ballets Russes-inspired collection of 1976.

Passementerie and braid closures on other looks had a militaristic flair. Naomi Campbell wore a slim column of black velvet that had something of an ecclesiastic air until she unbuttoned it to reveal a triptych Russian icon (see p. 249, top left and bottom left). More louche was Yasmeen Ghauri's feline-fronted gown (see p. 251), which brings to mind the lines: 'Would you like to sin / With Elinor Glyn / On a tiger skin / Or would you prefer / To err with her / On some other fur?'

There were historical references here, but the most impactful pieces were fantastical in their contemporaneity, like a Breton top made of vertical strips of fur (see p. 248, top left), and a grey Aran-knit turtleneck gown worn over a floor-sweeping skirt of white tulle (see p. 250). Its combination of craft and ease demonstrated the revolutionary tendency in couture at the time.

Tribute to Frida Kahlo

'Gaultier enjoys going to extremes' was the seemingly unironic title given to one review of the designer's Frida Kahlo-inspired ready-to-wear collection for Spring/Summer 1998. From the Mexican painter came elaborate coifs and dramatic brows, an openwork corset with straps (see p. 257), and floor-sweeping tiered skirts. Like the multiple selves in Kahlo's own artworks, Gaultier imagined different Fridas, some wearing colour and others all black. The apron-like looks were inspired by the artist's habit of borrowing the clothes of her muralist husband. The set design – which, critic Holly Hanson reported, resembled a 'Mexican fruit market, with a dusty plank floor and baskets of mangos scattered here and there' – also nodded to Kahlo's heritage.

But, as usual, the mix was not literal. The designer's recent visit to Cuba seemed to explain the use of cigars as accessories and some references to Che Guevara; black headwraps were Goya-esque, and the Catholic imagination was overarching. Some models appeared to have bleeding eyes, while others wore crowns of thorns.

More contemporary were Gaultier's oversized jeans with underwear peeking over the top (see opposite, top right) – a look borrowed from hip-hop culture, which is about as far away from Mexican folk magic and Catholic iconography as you can get.

Transported from the Mexican market on the catwalk to a deserted Californian lake, Madonna chose several looks from this collection to wear in the music video for her 1998 single 'Frozen', including the sheer black top styled with a long satin dress and statement cameo-style necklace (see p. 258, right) and the floor-length black satin coat with puffed sleeves (see p. 259).

Tuareg Marquis

Enlightenment-era thinkers of the 17th and 18th centuries took in ideas and influences from cultures far from Europe, including from China, India and Africa, romanticizing and Frenchifying along the way. In the same manner, elements from the nomadic North African and Tuareg cultures entered into Jean Paul Gaultier's Spring/Summer 1998 couture collection and set design.

As the *Evening Standard* reported, the designer 'took over a 17th-century convent on the Left Bank and his guests... entered a great hall hung with black Bedouin tents'. Headwraps designed to protect wearers from sun and sand were styled with the hothouse attire of the 18th-century French court. The designer's own Sun King, Tanel Bedrossiantz, sported a panniered Marie Antoinette-style get-up (see p. 264), while female models wore frock coats, one of which (see p. 265, top right) was cut out of standard-issue camouflage to which traditional floral embroidery was added.

'Gaultier has worked in couture for only a year, but his brave experimentation points to a canny awareness of the irrevocable hold that the streets now have on fashion,' noted Constance C. R. White, who explained that what looked like lace in this collection was actually achieved by 'cutting hundreds of little curves into fabric'. There were numerous such technical marvels: a toile de Jouy pattern was rendered in beads, and embroidered dragons swam among the swells of draped fringe on a skirt (see p. 263, right).

The Existentialists

To set the scene for his Autumn/Winter 'Existentialists' show, Jean Paul Gaultier 'brought in a jazz combo, seated guests at tiny bistro tables and pumped in enough smoke to choke the entire city of Detroit', wrote a journalist from that city, who went on to say that 'the models strolled through the crowd, pausing here and there to chat with guests, light up cigarettes or demand glasses of champagne'.

Some of these women resembled Juliette Gréco or Simone de Beauvoir, others Audrey Hepburn in *Funny Face*. The *Los Angeles Times* suggested that the designer – whom the *Evening Standard* had described as 'a cartoon Frenchman' – presented 'an affectionate parade of Left Bank stereotypes. Especially the earnest black-clad intellectuals we recognize from American movies set in Paris in the '50s and '60s.'

Despite the fictions, the clothes had undeniable real-life chic. There were many simple and straight silhouettes, long shirts and sheaths over pants. Materials (like fur and Peruvian knits) and techniques that would be displayed in the designer's 'Parisian Elegance' couture collection (see p. 272) were incorporated or adapted for ready-to-wear. A series of deconstructed looks also featured patchworked seams that had a sort of jazzy syncopation (see p. 269, right). In contrast to this undone aesthetic, pantsuits were worn with straight-out-of-the-box creases (see p. 268, right), and sophisticated Icelandic sweaters made of sequins surely gave life to desire, if not meaning to life.

Parisian Elegance

'Parisian Elegance' was an homage to the great French couture tradition, a celebration of texture and technical prowess. Naomi Campbell wore a pinstriped suit made of the finest bands of fur (see right); Esther Cañadas (see p. 274, left) modelled a plaid mohair skirt with a beaded Aran fisherman's sweater that took 1,000 hours of handwork to make.

Many of the pieces here were familiar from the designer's ready-to-wear, and indeed were built around wardrobe staples. A leather moto became a floor-length dress (see p. 275, left), as did a stunning trench coat with a removable bolero (opposite, top left). Feather-sleeved jackets had a closer provenance, back to Gaultier's couture debut (see p. 234), while a Peruvian sweater of plumes (see p. 274, bottom right) introduced a new look. Just four seasons into his couture career, *The New York Times* was referring to Gaultier's as 'the house that has become the new French standard'.

Divine Jacqueline

'I never had that thing of putting women on a pedestal that you cannot touch, or like a diva, or a caricature of that. I only want to show women that were friends that I was admiring,' Jean Paul Gaultier told journalist Lynn Barber around the same time that he presented 'Divine Jacqueline', a couture collection inspired by the renowned French beauty, the Countess Jacqueline de Ribes, who was present at the show, and who, *The New York Times* reported, 'had already ordered the outfit Mr. Gaultier called Confidence – a brown stretch sweater and trouser set that bares one shoulder'.

The long and lean silhouette preferred by de Ribes was the focus here, punctuated by some mermaid and flounced looks that fanned out at the models' feet. Fan dresses (see p. 288) seemed to hark back to the Belle Époque and the era of the *grandes horizontales* (courtesans). The bride (see p. 289, bottom right) wore a corset dress and carried a floral-bedecked fan in place of a bouquet.

The countess was not the designer's only icon: safari looks seemed to nod to Yves Saint Laurent (see right), and a disc-front jewelry dress (see p. 286, left) perhaps nodded to Paco Rabanne. A number of dresses were suspended from jewelled halters, and stacks of bangles seemed to reference African traditions as well as the British heiress Nancy Cunard. A pinstripe effect was created using intricate pleating (see opposite, bottom right), and a chiffon dress with an embellished bra top was backless, worn over pants (see p. 287, top right): Gaultier had played with this idea in his Spring/Summer 1997 ready-to-wear collection (see p. 230).

Raciest were two looks that had cut-outs at the crotch, which gave the suggestion that the model was wearing a thong bikini (see opposite, bottom left). The collection's *pièce de resistance* – a strapless gown made of upcycled jean pants with dégradé marabou skirt (see p. 289, left) – fits into Gaultier's trickle-up approach to couture (fast-forward to November 2024, when this dress sold at auction for 377,000 euros as part of the couture collector Mouna Ayoub's archive sale). As did the idea of a couture bikini, tank or cardigan, although it was the designer's more traditional tendencies that the press focused on. 'All of Mr. Gaultier's pent-up classicism is being released,' noted *The New York Times*. '[T]his rabble-rouser of design is producing the most classical haute couture, and it is stunning to see.'

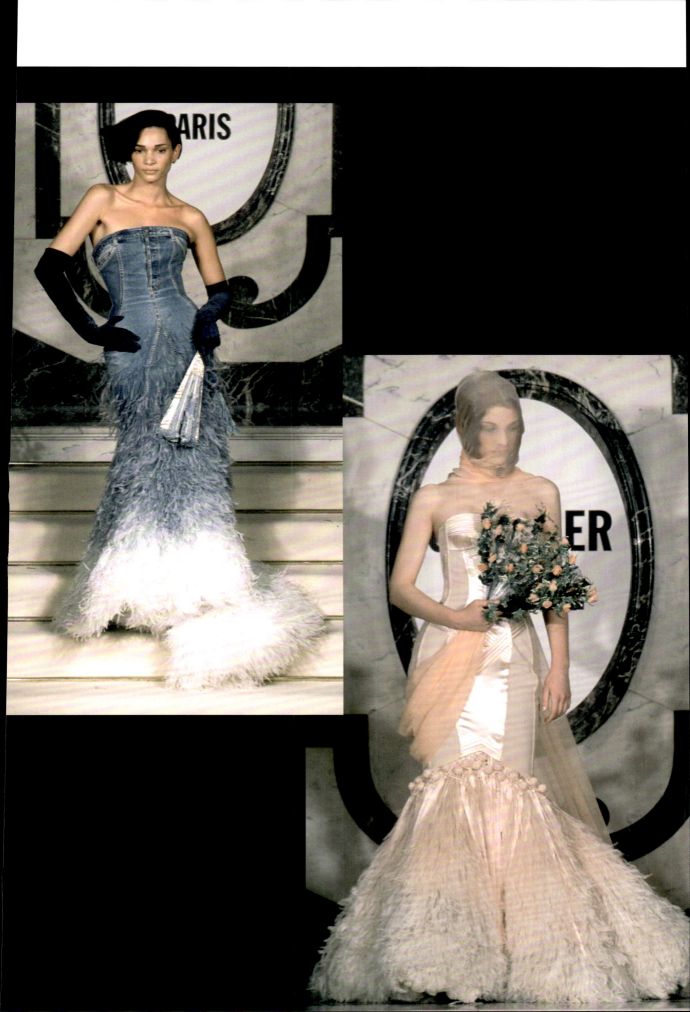

The Third Millennium Will Be About Love

Jean Paul Gaultier closed out the millennium with a 'love is all you need' dictum. It's a message that aligns more with a hippie than a punk ideology, but in this case it was directly linked to the designer's belief in acceptance and multiculturalism. Walking the runway in coordinating outfits were pairs of models; some were same sex, others mixed race.

Although the set, as critic Iona Monahan reported, featured a 'giant digital clock [that] ticked off the years from zero to 2000', and the show opened to the strains of the soundtrack to *2001: A Space Odyssey*, the designer was in a low-fi state of mind. 'I thought about the year 2000 and I didn't want to do science fiction. I wanted to show the evolution [of society] because it is the mixture of things that is right,' he told the *Montreal Gazette*.

The soundtrack transitioned to Viennese waltzes, creating a kind of *pas de deux*. 'Gaultier showcased a collection that seemed to plead for social and racial harmony and tolerance at the dawn of the new millennium,' wrote *The Toronto Star*, which reported that the designer received a standing ovation.

The lineup was in some ways a reprisal of the decade(s) that had come before. The Icelandic sweaters (see p. 292, right), fan shapes, brick-like patchwork (see p. 293, right) and sequinned plaids (see p. 292, left) all referenced recent ready-to-wear and couture collections. The straightforward format of the show allowed the duffle coats and other classic pieces, which were always present but usually overshadowed by theatrics, to take centre stage for once. They were 'garnished' with motocross looks, as well as tubular roll details at hems (see opposite, left).

This show demonstrated Gaultier's cross-gender approach to design – he once said, 'the treatment I did for women, I did the same for men' – and also underlined his faith in ready-to-wear, the type of fashion that is closest to the street, which is this designer's bailiwick.

The Love Boat

Jean Paul Gaultier's Spring/Summer ready-to-wear show, which opened to the strains of the *Love Boat* theme, was full of camp and tropicalia. The female cast, which reportedly included a number of drag queens, wore long, tacky nail extensions and flipped bouffant hairdos, some in acid hues like turquoise and cherry red. Hannelore Knuts walked the runway in curlers (see p. 300, top left). Prints were a main theme: a primary-coloured pattern that looked heat-mapped was most used, and there were others, including an interesting tie-dye.

The goings-on had a lot in common with the goofy slapdash humour of *Gilligan's Island*; the models were clearly meant to appear shipwrecked in style. While they found dry land, the collection itself was largely unmoored and headed in every direction at once. There were pirate shirts and flounces, a section of draped jerseys suspended from leather neck halters or waist yokes, and a lovely blue and white section in which denim was layered over floaty layers and had a boho festival girl vibe.

Critic Robin Givhan, who dubbed the lineup a 'wild mix of "The Love Boat" meets the Village People', reported that the extensive presentation was 'interspersed with wry humor, as when two star-crossed lovers ran – in dramatic slow motion – toward each other from opposite ends of the runway. But instead of a long embrace, he charged headlong into her outstretched arms and then tumbled down the catwalk.' Givhan also noted that 'a small "pond" was built into the sand-covered runway, and assorted sailor boys stood ready to escort the models down the runway'. At show's end the designer himself took a dip in the pond, making this show a drippy, as well as trippy, one.

Parisiennes

Jean Paul Gaultier conjured a dark and
smoky night, one in which cats roamed wet
streets littered with cigarette butts, for his
Autumn/Winter 2000–2001 collection that
celebrated the style of the Parisienne. This
wasn't a broad retrospective of her style,
but one that borrowed from the 1980s
(stirrup leggings, creased jeans), Yves
Saint Laurent (tunics, smokings) and Helmut
Newton's amazons. Models wore men's hats
and sometimes ties, and sported perfect red
lips: they commanded attention in leather
pants and dagger-like stilettos, and projected
an almost feline allure and aloofness. Notably,
they were smoking while what was playing on
the speakers, as Hamish Bowles reported for
Style.com, was 'a soundtrack featuring the
soothing words of an anti-smoking therapist'.

Androgyny was a sub-theme here: pinstripe
on the bias was used for a skirt paired with
a matching double-breasted stole. The
colours and the use of knits and furs felt very
autumnal. And the craftsmanship was pretty
incredible. Argyle patterns were created in
all-over sequins, and Peruvian-style motifs
were created using lengths of pleated ribbon
(see p. 308, left).

Louise Brooks Meets Easy Rider

It was as if Jean Paul Gaultier were playing two-handed chess when it came to his Spring/Summer 2001 ready-to-wear collection. He moved on from one bobbed muse (the Frenchwoman Kiki de Montparnasse; see p. 310) to another (the American actress Louise Brooks) with one hand, and then went a little bit country with the other. And although there was some heavy metal imagery worked into the lineup, this was one of the designer's most punk endeavours, at least in the sense that it had that 'slash and destroy' approach, what with one-sided dresses and half-jackets and what not. Oh, and his can jewelry was constructed from beer cans this season.

All of this took place in a dirt-covered corral, with some models carrying cans of brewski. The designer, reported the *Evening Standard*, 'transform[ed] the slick Carrousel du Louvre show venue into his own piece of Glastonbury, complete with mud-caked runway and "wall of sound" mega-speaker backdrop. Stomping out to a heavy rock classic soundtrack in scuffed-up biker boots, the models had obviously been briefed to show a whole lot of attitude.' *Newsday* quoted Gaultier saying, 'Everyone knows I can do real clothes, but I was finding that boring.' However, that sounds like subterfuge, because these clothes were intricately worked.

Lacy cut-out skirts were made of sequins, and slashed tops were twisted and stretched into open-work patterns of great intricacy. The lace inserts on the slip dresses were as fine and delicate as the leathers were beat-up and rough. Moreover, the half-dresses with straps that wrapped a few times around the body had a goddess-y as well as an armour-like aspect. Some of the unexpected combinations created were quite wonderful, like a half-lace frock with a Breton stripe (see opposite, bottom right). Critic Jeanne Beker suggested that this undoneness 'capitalized on the mood of duality that's so hot now'. We want to play both sides of the fence. In other words, to have the cake and eat it too. How very like Marie Antoinette.

Jean Paul GAULTIER

Cutters

Jean Paul Gaultier took on the role of Edward Scissorhands for his Spring/Summer 2001 'Cutters' couture collection, which mixed precision tailoring with softer, more feminine touches, like micro-beading. Essentially the slashing and openwork he had introduced at ready-to-wear (see p. 314) was elevated and refined here more gently. 'Now that I have been in fashion for 26 years, I can do something that's more delicate, less aggressive,' the designer told Style.com. 'I wanted to be suggestive and play with what is visible and what you have to imagine – clothes that give the impression that they are falling off the body, or that occasionally reveal a flash of skin.' This sense of undoneness was purposeful; the 'she's coming undone' effect was created with consummate skill.

Gaultier's play with opposites took many forms. There was the inside/outside conceit, as when he lined a trench stole with floral silk. Then there was the 'business in front, party in back' trope. A big square was cut out of the back of the shapely, but fluid, black pantsuit worn by Noémie Lenoir (see opposite, top right). The British press were beside themselves over Sophie Dahl's full-length pink corset dress (see p. 321), made in collaboration with Mr Pearl 'from the pink ribbons used to tie ballet shoes', according to *The Guardian*. The back was all peek-a-boo-laces, and it apparently took more than an hour to put on. Another intricate corset, worn by Julia Schönberg (see right), had almost honeycomb cut-outs that bared the skin.

Contributing more of a free-flowing romantic feeling were a number of floaty pouf dresses. Then there was the hair, by Odile Gilbert, all soft curls loosely gathered with bouquets of flowers. Jade Parfitt in a flounced and floral dress looked like a walking Botticelli (see p. 320, left). She closed the show in Madonna mode, draped in white and carrying not the Christ Child but rosy-cheeked five-month-old Eloi Ducrot.

Puzzle

It's difficult to imagine Jean Paul Gaultier
having the time to complete a jigsaw puzzle
(that was the format of the invitation). Still,
he loosely translated the idea into a collection
of layered mix-and-match separates for his
Autumn/Winter ready-to-wear collection.

Writing for *The Washington Post*, Robin
Givhan noted that the soundtrack to the
show, 'an eclectic mix of rock and funk by
Prince, was the perfect background for the
clothes, which had a soulful rhythm of their
own. One also couldn't help but note that
the musician himself seemed to provide some
design inspiration, as there were plenty of
his signature tight pants, boleros and even
a jumpsuit with cutouts along the side.'

Models walked a runway laid with white
pile in pieces in convertible designs –
sleeves might be attached with clips, jackets
transformed into boleros – and abbreviated
ones. The designer cut out the middleman,
as it were, showing cropped jackets with
short skirts of the same fabric, often layered
over matching pants. Softening the look were
small bouquets of violets, which were tucked
here and there in the models' ensembles.

'The idea was to make clothes that can be
made as you want,' explained the designer.
'You can take them apart and put them
back together in different ways. It's about
freedom!' You might even say this was
a pro-choice parade.

China and Spain

'The idea was to bring together everything that you imagine when you think of China – theatre, movement, color, history and richness,' said Jean Paul Gaultier of his 'China and Spain' couture collection. That 'everything' was highly stereotypical, as was the reporting of it. 'Madame-Meets-Ming: Fantasy fall couture line shows off designer's talent' read one contemporary headline.

New York Times critic Cathy Horyn wrote: 'His models looked like ornamental dolls, swanning out in red lips and painted-on eyebrows, with black lacquered cocktail umbrellas fanning from their shiny heads. Yet there was nothing childlike about Mr. Gaultier's grasp of the sexual fantasy quotient or the way he nudged it along, suffusing the sultry with wary sophistication.' If the rouging of an exposed nipple looked gratuitous, other cut-outs and peek-a-boo treatments came from the designer's existing playbook. Elements from his most recent ready-to-wear collection (see p. 322) were also revisited, and there were hints of his use in the 1990s of patterned silks, like those that were cut into cigarette pants (see opposite, bottom left); the same type of fabric was used to line a classic trench coat (see opposite, top left).

There were many high waistlines, but what was newest were the extremely low ones on pinstripe and other trousers. Mixed in with all the Chinoiserie were some references to the decorative garb of Spanish matadors; and some of the fringe was perhaps a nod to flamenco. It should be noted that Madonna was at the time performing on her *Drowned World* tour, in which she wore both Ming- and matador-inspired costumes. Coincidence? Not a chance.

Peace and Love

'Now is not the time for fashion to offend,'
wrote the fashion critic of the *Toronto Star* of
the Spring/Summer 2002 European ready-to-
wear collections, which were presented about
a month after the unimaginable events of 9/11.
The designs that walked down the runway
had, of course, been created months earlier.
On some levels, Jean Paul Gaultier's 'Peace
and Love' theme didn't need much editing,
as its message was an amelioratory one:
'I've always been inspired by different
cultures, and I discovered that in Buddhism
orange is the color of peace and liberty,' the
designer told Style.com. 'I wanted to convey
a positive message of global communion.'

This co-ed collection was massive and
contained an extraordinary amount of
sub-themes, some of which were more in
the mood of the moment. Elements of (sexual)
libertarianism in this collection, including
rouged nipples carried over from couture
(see p. 326), and lace-trimmed camisoles
and bras for men, fit into the Gaultier oeuvre.
More interesting was how lingerie details were
combined with sari-like construction. The
same might be said for the combination of
pinstripe (a symbol of Wall Street capitalism)
with a spiritual theme. Blue-collar workwear
was also represented via overalls, and tanks
with overall-fastenings at the shoulder.

The main message seemed to be softness,
with lots of wrapping, draping, shirring,
tiers, tie-ons and ruffles. Add to this the
easiness of sweats dressing, which was
related to boxing references. Electrodes as
accessories recalled the designer's Spring/
Summer 1996 collection (see p. 222), much
as the collaged prints seemed to hark back
to the Constructivist lineup of Autumn/Winter
1986–1987 (p. 108).

In hindsight Gaultier's use of deconstruction,
like waistbands separated from the tops of
pants, and his repurposing of sheer nylons
to create draped bias strip tiers on interwar-
style dresses, might have been most in tune
with the 'make do and mend' mindset required
of the moment, to which the designer added
a touch of spiritual healing.

Ze Parisienne

'Saint Laurent is the supreme reference, the greatest, whom I admire and I revere,' said Jean Paul Gaultier, who many considered to be the 'heir' to the designer, even before the latter announced his retirement on 7 January 2002, days before the Spring 2002 couture showings. Though they represent different Parises, both men are inexorably tied to the city. The names of the looks in Gaultier's show referenced Parisian icons, places and monuments.

There was a bit of Moulin Rouge sauciness in the deep décolletages of bosom and bottom; Naomi Campbell made one exit in a high-waisted skirt and red-beaded beret, cupping her breasts in her hands (see right). Gaultier also melded *marinière* stripes and 'tattoos' in a nearly naked dress with insets of figurative navy lace (see p. 335, left).

It can't be by accident that the designer – who showed the collection, as Style.com reported, 'in his new headquarters, a turn-of-the-century worker's club called L'Avenir du Prolétariat ("the future of the working class")' – presented so many looks, including a corset made with neckties, a symbol of the white-collar executive, and the *foulard* material they are made from (see opposite, bottom right). Also 'borrowed from the boys' were watch chains; instead of being attached to timepieces, they connected to a single golden handcuff (see opposite, top right).

Gaultier made free use of beading, constructing a white mesh tank entirely of ant-sized white beads. The model carried a mesh market bag filled with, what else, tin cans. Similarly, Carla Bruni wheeled a market bag that had also been festooned. Many pieces consisted of strips of material connected by beads. One of the most fantastic examples of this (see p. 335, bottom right) was a deconstructed jean jacket with wing sleeves that looked shredded, but in fact had row upon row of swagged lines of beads between the denim ribs.

The closing look was a corset dress covered with real plants, perhaps sending the message that love, and haute couture, continue to live, and thrive.

The Christo Effect

This collection takes its name from the husband-and-wife team of artists Christo and Jeanne-Claude, who are most famous for wrapping buildings and creating site-specific installations. This being a Jean Paul Gaultier show, however, the idea of wrapping and shrouding was loosely connected to dry-cleaning (think plastic-wrapped garments), and a rotating rack like the one you might find in your local shop formed the set design. Models hung pieces of their layered and convertible ensembles on it that were then swept backstage. 'The collection is about everything that is packaging,' the designer told the *Los Angeles Times* critic, who wrote: 'Gaultier said he employed the clever idea to help show what's underneath the veil of our coats. More important, he illustrated how a woman can be in command of her own style. She can add arm warmers, tailcoats, mesh T-shirts.'

Many looks were indeed swaddled, but ultimately the collection once again argued for separates dressing, which is very much tied to ready-to-wear. Signature tropes included stockings showing over waistbands (see p. 338, right); newer were sack-shaped skirts with grommets (see p. 339, left), rather like sailors' bags, that could be adjusted with slip-on straps. As Marylou Luther noted in *Newsday*: 'Paris fashion has gone to pieces. Pieces of the past. Pieces of other cultures, other times. Pieces of intarsia and patchwork. Unlike those all-of-a-piece sleeveless dresses and matching jackets or coats of the minimalist years, this new kind of fragmented dressing encourages individuality. As Jean Paul Gaultier said, "In a world of conformity, singularity is the greatest luxury."'

The Hussars

'The Hussars' couture collection opened with a scene that was somewhat reminiscent of Helmut Newton's provocative 'Rue Aubriot' photographs that appeared in French *Vogue* in 1975. These were taken at night on the street in Paris and feature an androgynous female model in an Yves Saint Laurent smoking, who falls into an embrace with a female model who is naked save for heels and a hat. In this case, the model Omahyra Mota opened the show in a black pantsuit and grey cashmere overcoat, which she placed lovingly around the shoulders of model Michelle Alves, who was sporting a Veronica Lake hairstyle and wearing Look 2, a pink velvet slip dress through which a chain had been threaded to hold its side drape (see right). Look 3 was Jean Paul Gaultier's muse Julia Schönberg in a black pantsuit with a beaded trompe-l'oeil shirt depicting a naked female torso with a necktie (see opposite, top left and bottom left). It's safe to assume that gender, power and passion were themes of the season. 'She has a lot of lovers, a lot of imagination to play with!' Jean Paul Gaultier told Style.com. While music by Liszt and Strauss filled the room, guests could concurrently opt in to headphones that played a recording of a reading of the racy *Story of O*.

The designer imagined a female libertine, and then added some overlays. As critic Sarah Mower observed, 'a sequence of sophisticated British menswear tailoring gave way to a display of Austro-Hungarian fin-de-siècle romanticism'. Cathy Horyn of *The New York Times* made note of the designer's use of deconstruction, writing that Gaultier 'kept undoing things... until the mistress had taken over the man's life and was wearing his military coat as a triumphant skirt. Deconstruction is now part of couture. Gaultier's feat was to show how it could be done elegantly.'

The title of the show – a reference to Central European cavalrymen, and their fashionable uniforms – explained the beautifully worked military jackets and coats, like the fur-trimmed and frogged teal velvet coat that Delfine Bafort wore backwards and suspended from one shoulder like a dress (see p. 343, left). Some looks (jackets and cropped pants) continued in the Spanish vein the designer had introduced for his Autumn/Winter 2001–2002 couture collection (see p. 326). A superbly cut crocodile jacket, with the reptile's tail kept intact as a train (see p. 342, right), seemed to nod to Gaultier's backers, Hermès.

Intake of Air –
Thank You, Calder

Acrobats in rings, models on a swing, and a backdrop that evoked a circus tent: this was Jean Paul Gaultier's playground for Spring/Summer 2003. One of the designer's references was the mobiles of the American sculptor Alexander Calder (and perhaps his famous flea circus as well), and there were garments that were Frankensteined together, the different parts attached with hooks or chains. The show title in French, 'Appel d'air – Merci Calder', provides a neat rhyme (air/ Calder), and the expression 'appel d'air' can also convey surprise, or an explosion – both concepts familiar on Gaultier's runway.

The designer's main conceit, however, was a visual pun/commentary on the trend for low-rise pants. Outdoing even Alexander McQueen's infamous bumsters, Gaultier showed pants too tight to fit over the bottom and so low-waisted they extended only to the top of the thigh (see right). The legs, however, were extremely long and worn scrunched. The brevity of these skinny pants left not just thong straps exposed, but all or most of the panty or stocking top. Belt-width miniskirts (see p. 348, right) covering these exposed parts were offered as sartorial band-aids. (It seems worth noting that when Miu Miu offered similar-width skirts for Spring 2022, they went viral.)

'Hang a medal on Gaultier for the belt-size pleated miniskirts worn over super-skinny pants and, most of all, for the East-meets-West kimono-sleeve silky sport jackets with embroidery on the back' (see p. 349, right), wrote Sarah Mower at the time. The designer had included one in his couture collection months before (see p. 340, specific look not pictured) and they appeared in his prêt-à-porter the same season that Yohji Yamamoto and Adidas's collaborative line Y-3 debuted on the runway. Gaultier had always played with sport and this season showed polo shirts with ragged tulle skirts instead of a moto. Shirts and jackets worn backwards (see opposite, bottom left) continued another theme from Autumn/Winter 2002–2003 couture (see p. 340); bib overalls and saris were put back into rotation as well.

Buttons

Was Anglo-French diplomacy at play in Jean Paul Gaultier's Spring/Summer 2003 couture show? Titled 'Buttons', it seemed to reference the British Pearly Kings and Queens, people of modest means who dress flashily in clothes covered with nacre buttons to raise money for charity. Critic Cathy Horyn was of the opinion that '[b]uttons embroidered on chiffon gave a hint of a poorish elegance'. In contrast, Sarah Mower, writing for Style.com, connected the buttons to the designer's interest this season in 'Atlantis and ancient Greek mythology', reflected, she noted, in 'magical underwater colors' and 'headdresses that looked like sea anemones', as well as in 'mother-of-pearl buttons'.

In any case, Gaultier, as is his wont, spun out several different narratives, one involving dresses that were constructed like cobwebs. He explored 'the threads that bind', with references to the history of fashion. A shocking pink dress was named 'Elsa' after Schiaparelli, whose signature hue it was. And a jacket with structured hips, worn strapped onto the body, with lily of the valley in the pocket, nodded to Christian Dior's Bar jacket and favourite flower (see opposite, right). Comparisons between Gaultier and Yves Saint Laurent were always being made, and were repeated again this season because of the smart tailoring sent out and because, as Reuters News Service reported, Gaultier had hired many of the seamstresses made jobless by Saint Laurent's retirement.

Any homages were just that, nods; it was very clear who designed this collection. Who but the lingerie-obsessed Gaultier would design a black suit and show it with a pink camisole with lace trim, and have the model open the jacket to reveal it to be lined in the same pink material with lace embroidery on the inside (see opposite, bottom left)? Ditto with the leather moulded into female torsos (see p. 352, top left). Continuing on the art tour that kicked off with Christo for Autumn/Winter 2002–2003 ready-to-wear (see p. 336), Gaultier continued with the Calder theme introduced for Spring/Summer 2003 ready-to-wear (see p. 346) and threw in a Degas dress for good measure (see p. 353, bottom right).

Gaultier's own talents for mixing high and low were on display in a series of workwear pieces – an orange boiler suit, cargo long shorts, a 'denim' jacket (see p. 352, bottom left) and bib overalls – that were entirely beaded. A less dramatic trompe-l'oeil effect than the 'floating' ensembles, these brought the couture even closer to the real world.

Baby Doll

'The collection is about growing up...
but always remembering the child in us,'
said Jean Paul Gaultier at the close of his
'Baby Doll' show, which opened to the sweet
sounds, reported the *National Post*, 'of a
children's choir singing "Good Vibrations"'
and closed with the designer taking his
bow holding a plastic doll that was of the
same type as 'the 800 lined up in marching
order below his glass runway', as reported
by *Newsday*.

Some of the models who strutted over
them wore garments that referenced
childrenswear, rendered in adult materials
like suede, leather and fur. Frilled bloomers
and playsuits (Jade Parfitt's leather number
was paired with garters worn over tights;
see opposite, top left) had a wink-wink touch
to them. And there were button-front sailor
pants (a staple of turn-of-the-century
boyswear), Peter Pan collars, and puff sleeves
galore. Pockets were shrunk on a dress, and
bags were shown in mini proportions. Like the
paper doll and wardrobe that were sent as an
invitation, some of the figures on prints were
dressed with sweaters and hats embroidered
atop mesh. Yet this was not a one-note show;
yes, there were pom-pom hair decorations
and paste tiaras, but also in play were
razor-blade-shaped earrings and necklaces.
Sub-themes included sportswear, particularly
hoodies worn under tailored suits, and in
hand-knits and legwarmers and patterned
winter sweaters there was somewhat of
a Tyrolean theme, an oldie but goodie in
Gaultier's oeuvre.

This show participated in what the
Toronto Star identified as 'the trend to
let women dress according to their own
dictates', but which is one of Gaultier's
main preoccupations. More timely was
the designer's casting of Natalia Vodianova
(see right), who Sarah Mower described as
'fashion's favorite child-woman', and who
would appear, two months later, in American
Vogue's famous 'Alice in Wonderland'
editorial, in which Gaultier appeared in the
character of the inscrutable Cheshire Cat.

Morphing

The pipe carried by Julia Schönberg, who was the second model out in Jean Paul Gaultier's Autumn/Winter couture show (see opposite, top left), could only have been a reference to René Magritte, whose famous 1929 painting, *The Treachery of Images*, considers the nature of reality by stating, 'Ceci n'est pas une pipe'. This season, Gaultier asked us to question where skin meets fashion.

The same models walked twice: first in dresses, suits, coats and other marvellously worked pieces, many referring to past collections, and then again in the custom bodysuits they had worn under each (see before and after: opposite, top right and opposite, bottom right; p. 361, top right and bottom right). Gaultier, wrote Sarah Mower, 'was inspired by the twin notions of high-tech morphing and surrealism. He took the current trend for long boots and grew it out of all sane proportions into hooded skintight bodysuits.' These 'second skins', noted critic Cathy Horyn, meant that the designer was 'not only giving another dimension to the body... he was also creating a new surface to merge and contrast with the clothes'.

Unlike the Vasarely-inspired stretch bodysuits from the Autumn/Winter 1995–1996 'Mad Max' ready-to-wear collection (see p. 216), which were sporty and slightly cyborg, each of these bodysuits was unique, befitting the couture context, as were the fabric-wrapped accessories inspired, said *The New York Times*, by the playful Dutch product and furniture designer Jurgen Bey, who imbues common objects with irony and magic. A man after Gaultier's heart, then.

Tribute to the Beauty of Redheads

The year 2003 was a banner year for Jean Paul Gaultier: he launched cosmetics for men, and it was announced that he would succeed Martin Margiela as the creative director of Hermès, a French institution. This prompted reporter Robert Janjigian to observe that 'to a great many people in France today, Gaultier is more than a fashion designer. He is a leading cultural figure.' At the same time, his Spring/Summer 2004 ready-to-wear collection found him exploring familiar territory and reverting to his *enfant terrible* persona to snub conventional good taste.

He chose as his heroine the redhead, though not a romantic 'ginger' like those found in Pre-Raphaelite paintings, but a rowdy, punkish cowgirl. All of his models sported short-cropped spiky hair and freckles. And they wore clothes that called on three main themes in the designer's arsenal: corsetry, sports references and Western wear. As Janjigian put it, Gaultier 'embraces the cowpoke and the saloon-girl, sometimes in the same ensemble'. There was a lot of emphasis on the hips, with corsets worn layered over garments – innerwear as outerwear once again.

There are different ways to parse the designer's tendency to carry things over. He upcycled materials and applied couture techniques (see the button trims and lacing) to the ready-to-wear. The level of craft is indeed incredible. One muslin-like fabric looked like it had been punched with a train conductor's ticket punch. And these small openings were thematically related to the skin-revealing lacing on elaborate corset-inspired looks and the cutwork on leather cowboy boots. There has always been a method to Gaultier's 'madness', even when it took him down paths unrelated to what was happening in the greater world of fashion.

Samurai

The Last Samurai, one of the highest-grossing movies of 2003, inspired Jean Paul Gaultier's Spring/Summer 2004 couture show, in which the designer employed his expertise in corset lacing to a different end. 'I worked on samurai armor but the clothes are not for warriors, they became very feminine,' Gaultier told Suzy Menkes. Yet this was not a monothematic collection. *The Independent* described the show, which included references to African, Indian, Indigenous, Rastafarian and Latin cultures, as a 'round-the-world-in-a-day trip', and noted that 'the collection added more weight to the view that Gaultier is the only designer to have hit upon a truly modern definition of couture'. Sharing space in this collection was a perfectly tailored pair of cuffed khaki pants, an immaculate black skirt suit tied with a bow (see opposite, top left), shagreen cut into lace (see opposite, bottom left), and any other number of wonders. The workmanship was astounding, rather than camp.

While the 'Samurai' show introduced discussions about appropriation, fashion was not yet at that place. The same season that John Galliano presented latter-day Cleopatras, Menkes wrote of one of Gaultier's models that '[h]er ethnicity was certain: a creature from Planet Haute Couture'. Richard Dorment, *The Daily Telegraph*'s art critic, wrote that the model cast recalled the 'monstrous brigade of women who confront us in Picasso's first cubist masterpiece, *Les Demoiselles d'Avignon*. Here was the same vision of European women seen through the prism of African tribal art, the same confrontational aesthetic, the same fascination mixed with fear of women's bodies.' Still, there is an approachable wearability to some of the pieces in the collection that suggests that they were created, through the practice of the high French art of haute couture, to go out into the world. Yet Dorment's observation is indeed interesting: the bride who closed the show (see p. 371, top right) wore a headdress that, seen from certain angles, looked like the profile of a face.

Puppets

WWD reported that Jean Paul Gaultier's show notes were printed with the statement 'Each garment has its own truth', which might have been the designer's take on René Magritte's 'Ceci n'est pas une pipe', as many of the looks were made using trompe-l'oeil prints. Nothing was as it seemed: moto jackets were extended into dresses (see right), woven plaids mixed with printed ones. A naked-print bodysuit was worn under a fur bikini (see p. 374, left), and crying eye and lip brooches seemed to nod to Salvador Dalí's jewelry designs.

The biggest surprise was the cast, which consisted of a handful of living and breathing models and a cadre of marionettes operated by real-life puppeteers out of eyesight, both wearing, for the most part, face-printed head wraps. Their motion recalled the moving dry-cleaner's conveyor belt that Gaultier used for his Autumn/Winter 2002–2003 ready-to-wear show (see p. 336).

On a different note, this was the same season that Gaultier succeeded his former protégé Martin Margiela at Hermès, that bastion of good taste and quality, with which the designer always danced a tempestuous tango. Perhaps what Gaultier was also implying is that 'Each *designer* has their own truth'. As to the border between self and identity, skin and clothes, the jury, this collection suggested, was still out.

Cloak and Dagger

Jean Paul Gaultier, a sponsor of the 2003–2004 'Bravehearts: Men in Skirts' exhibition at the Costume Institute in New York, imagined women in cloaks and daggers for his Autumn/Winter couture outing. It's not the first time the designer was in a swashbuckling mood; he built some earlier collections on the theme of Robin Hood (see p. 28) and the Bond Girl (see p. 38), but this time the ante was high; this was couture, and all of this posturing, mind you, was done in high heels – *cuissardes*, boots with spurs, or sandals and leggings.

Models portraying 'cavaliers, cowboys, musketeers, highland heroines, centurions, highwaymen, and knights', wrote critic Hilary Alexander, walked to a soundtrack that layered Western movie themes with 'sounds of anvils striking and hooves pounding'. One elaborate beaded dress featured, accordingly, what looked like hand-forged anvils (see p. 379, left), and the equestrian references seemed, to some viewers, to allude to the designer's new position. 'I suppose it was Hermès couture in a way,' the designer told the *International Herald Tribune*, 'but I have always done cavalier women, and I liked the idea of strict tailoring with capes giving a sense of liberty.'

Parisian Gypsies

About five years into the 2000s, there was a
shift in Jean Paul Gaultier's work. Distanced
from the street and having worked through
some art themes, the designer became more
singularly focused on a theme or a technique:
'Parisian Gypsies' is a good example of that.
The main conceit was to layer pieces over full,
tiered flamenco skirts, some in patchworked
fabrics. Scarf-tied heads, some high-waisted
pants, and espadrilles, some high-heeled,
contributed to a bohemian, Latin vibe, while
the Gitanes smoked by the models fragranced
the runway (and also recalled the cigars of
the designer's Frida Kahlo-inspired show;
see p. 252).

Look 16, a white-piped pyjama jacket
with draped lapels and a cinched waist
(see opposite, right), demonstrates one of
the technical feats of the collection. This
topper has pieces of lingerie-stretch material
sewn inside the jacket that connect with
hook and eye, creating a waist curve. When
this centre-front closure is made narrow
and applied down the front of a dress or skirt
with horizontal gathers, it recalls the 'Sirène'
or 'Lobster' dress of the Anglo-American
couturier Charles James, who, like Gaultier,
was a consummate nonconformist.

Tribute to Africa

Jean Paul Gaultier's intent with his Spring/
Summer 2005 couture collection was, as the
title indicated, to pay homage to Africa. But
while the construction of the mask wedding
gown (see p. 387, bottom right) was incredibly
intricate, it could be argued that Gaultier
followed much the same path that had
been trod in art by the Cubists, who found
inspiration in carved wooden masks, and in
fashion by Yves Saint Laurent, who presented
his take on Africa for the Spring 1967 couture.
In a 2023 interview, Gaultier said of his 'Chic
Rabbis' collection, 'I'm not sure you could do
something like that today,' and perhaps the
same is true for 'Tribute to Africa'.

Like Saint Laurent, Gaultier included tailoring
alongside more imaginative, and colourful,
eveningwear. And there were other themes
at play, too: a 'fox' stole made of raffia paired
with a slimline dress channelled the '40s, and
there were white dresses with a Deco feeling.
Naomi Campbell wore a brown beaded suit
with raised floral motifs in a Chinese style
(see opposite, left); similar blooms were
embroidered in white on a transparent black
dress. The first look, a red suit (see right),
seemed to combine elements of Hussar
military uniforms with African embellishment
in the form of conical silver fastenings.

Glam Rock

There were some hit singles in Jean Paul Gaultier's 'Glam Rock' collection, but it never came together as an album, as it were. With the benefit of hindsight, one can see threads of various projects coming together in this Autumn/Winter 2005–2006 collection. The designer had released a limited-edition Classique Rock Star fragrance around this time, and had chosen a Russian theme for his Hermès collection, which might explain the respective presence of glittery makeup, David Bowie haircuts, skinny scarves and fur hats à la *Doctor Zhivago* in his namesake lineup.

Besides the soundtrack, which included T. Rex's songs '20th Century Boy' and 'Children of the Revolution', the most glam aspect of the collection was the second-skin leggings, many covered in sparkling sequins or otherwise shining. 'It's all about the legs: Plain legs, sparkly legs,' the designer told the *National Post*. 'The idea with these leggings is you can add anything you want from your wardrobe.' And there were any number of wonderful toppers to choose from, including trenches with frilled collars (see opposite, bottom left) and a knockout wool jacket worn by Liya Kebede that had velvet smocking and gold embroidery (see p. 390, bottom left). It was difficult to see how lingerie details, in the form of ribbon-threaded lace or gold-starred embellished white tulle fit for a latter-day Estella Havisham, fit in the larger picture, but the asymmetric hems of tailored coats were as sharp as a record needle.

Tribute to Ukraine and Russia

To an audience that included the then
First Lady of Ukraine, Kateryna Yushchenko,
and her daughter, and which was treated
to caviar and vodka, Jean Paul Gaultier
presented a paean to that country of blue
skies and yellow wheat – and more generally
to Eastern Europe. Critic Hilary Alexander
described the collection as a 'fairytale from
the steppes', and indeed it was a romantic
exercise, one which featured military garb,
vyshyvanka (the Ukrainian national dress),
outsized fur *ushanka* hats, Mongolian
influences, and embroidered Romanian
blouses like those painted by Henri Matisse
(after whom one of the looks was named).
There's no little irony in the fact that this
exquisite display of Parisian savoir-faire
was somehow connected with Gaultier's
visit to Kyiv as a guest of the Eurovision
Song Contest, a distinctly camp pop-
culture phenomenon.

As usual, Gaultier also referenced himself:
as Style.com's Sarah Mower noted, the
designer revisited 'the swirling, tiered gypsy
skirts that were the massive hit of his own
spring ready-to-wear line' (see p. 380). An
iconoclast, Gaultier had always shown an
affinity with alternative lifestyles, be they
punk, bohemian or non-gender-conforming;
at the same time, he was able to disrupt the
bourgeoisie codes because he knew them
inside and out. It might even be possible
to draw some parallels between Gaultier's
practice and those famous Russian nesting
dolls, as there are always layers of meaning
and surprise reveals in his work. In this
collection, fiction and fact mingled, and
the past was reinterpreted for the present.
For Autumn/Winter 2005–2006, Gaultier's
vision was aligned with that of Yushchenko,
to build bridges between East and West.

Countryside Beauties

Critics were right to see Jean Paul Gaultier's Rousseauian pastoral collection as a continuation of the Ukrainian theme around which the designer had created his Autumn/Winter 2005 couture collection (see p. 392). Yet the show – which opened to 'chapel bells and the sounds of a folk song', according to *The Hamilton Spectator*, and had models walking a hay-strewn runway – saw the designer also returning to the theme of French folk, a subject he had addressed in his Spring/Summer 1986 collection (see p. 102). Many of the headdresses were inspired by traditional Breton costume; the bird and alphabet embroidery on peasant shirts recalled samplers made by young women.

In 2004, Gaultier had exhibited his 'Pain Couture' (garments made out of loaves of bread) at the Fondation Cartier in Paris, and the experience seemed to have become ingrained in the designer's imagination, as wheat (from which flour is made) made various appearances throughout the collection, starting with the opening look: a raffia and lace corset with ornamental beards of wheat (see right). The grain was embroidered in gold on a white skirt, and necklaces and tassels on shoes mimicked its bearded form. Gaultier also referenced the red poppies that grow by the side of golden fields of grain. The rusticity of the lineup was broken up by citified looks such as pinstripe suiting and trench coats. And the designer didn't neglect the call of the sea; he outfitted a model family in Breton stripes (see p. 401).

Tribute to Greece

'He likes a travel theme, and a strong woman, Jean Paul,' wrote critic Sarah Mower of the designer's Spring/Summer 2006 couture show. Titled 'Tribute to Greece', it was presented in a room hung with lanterns and decorated with hookahs, and the catwalk, reported the *Evening Standard*, 'was divided into sections named after Greek islands (Paxos, Lesbos and Kefalonia)'. The experience, from the setting to the clothes, as *The Independent* snarked, was 'a mish-mash from the Mediterranean'. Byzantine and Eastern European influences commingled with those from the ancient past and pop culture – the eye makeup, for example, came from Maria Callas.

To be fair, by placing a jewelled ship brooch in the hair of the model who opened the show (see right), Gaultier seemed to be thinking of Hellas as a centre of trade and a melting pot. Look 1 clearly referenced the elite Greek evzone soldiers; the designer reimagined their full fustanella skirts as collars on a *marinière* set (see opposite, top left) and the bride's gown. Gaultier's favoured cage technique, here executed with beads (see p. 407, left), had something in common with Leon Bakst's costumes for *Scheherazade*.

The constructed body, especially the corseted one, has always interested Gaultier more than the natural body as depicted in ancient sculptures. (This is a point of commonality between Gaultier and Madame Grès, whose draped jersey gowns often had internal support.) The couturier did borrow the pleating associated with loosely flowing 'goddess gowns' and used it to his own ends. Look 20 was a ravishing white corset with quilting and pleats that opened into frills resembling seaweed (see opposite, bottom right). The pleats on a dress of airy brown fabric (see p. 407, bottom right) swelled and ebbed like a tide; think of Grès, but warped. Byzantine touches were introduced via jewelled belts and gold embroideries.

The crowning touch, in terms of press coverage, was the presence of Madonna, who had tapped Gaultier to make costumes for her *Confessions* tour. The star arrived an hour late, and at the close of the show, when the designer and models were showering the audience with flower petals, reported the *National Post*, 'Madonna whispered to the designer, "What about me?" whereupon Gaultier threw the rest of his basket of petals on her head'.

Sleepy Hollow

Jean Paul Gaultier had always been a cinephile. He once told French *Vogue* that it was the 1944 *Falbalas* 'that made me want to be a designer and part of the fashion world full of clothes, fittings, muses and so on... the film paints a beautiful picture of the profession'. By the aughts, Gaultier was an establishment figure and mining films for inspiration. *The Last Samurai* (2003) and Tim Burton's 1999 *Sleepy Hollow* influenced the designer's Spring/Summer 2004 couture (see p. 366) and Autumn/Winter 2006 ready-to-wear collections respectively.

The clothes were presented in a room with 'gray veiling floating from the ceiling – and horses whinnying, wolves howling and crows squawking from loudspeakers', reported *The Daily Telegraph* before the music director cued up the *Nightmare on Elm Street* soundtrack. 'Sleepy Hollow' is an adaptation of a 19th-century tale and there were touches of Victoriana throughout the collection in the form of lace-trimmed cravats. The back fullness of many of the looks could be seen to relate to old-time bustles, although there was nothing old-fashioned about Stella Tennant's skirted pea jacket (see opposite, bottom left) or an A-line trench cinched with a leather corselet (see opposite, top).

What critics described as a 'ghostly' feeling was partly created by Gaultier's use of transparencies. Nylons were worn over shoes, encasing the leg, and there were many bubble-hemmed looks, some with a sheer top layer over an opaque body. Chandelier crystals were caged in a tulle top (see p. 410, top left), and the same material was used to shroud a fur coat. Models' hair was powdered, and some carried doppelgangers in the form of porcelain dolls with mini-me looks. One model in a black velvet *vyshyvanka*-style top embellished with gold sequins was escorted by an owl (see p. 411, top left) (echoes perhaps of the falcon from the Mad Max show; see p. 216); others held cats, or walked dogs. In each case, there was a correlation between animal and human. An Aran-knit dress with deep floor-sweeping fringe, for example, appeared alongside a Bergamasco shepherd dog (see right). *Avoir du chien*, indeed.

The Surrealists

Subtlety isn't usually Jean Paul Gaultier's
calling card, but he was fairly restrained
with his Autumn/Winter 2006–2007 haute
couture collection, despite it being titled
'The Surrealists'. The Fair Isle-ish opening
look (see opposite, top left), for example,
was more suggestive of a Highland fling
than an automatic writing session. Its one
'off' note was a hat made of hair, which
many subsequent models also sported.

The leap from hair to fur to feathers isn't
a giant one, and there were several woman/
bird hybrid looks (see right) – a reference
perhaps to the parrot ensemble that appeared
in the designer's first couture collection
(see p. 234). More intriguing, and unexpected,
was the transposition of model into
chandelier, as in several exits and the finale.
For some reason these bring to mind Jean
Cocteau's famous *La Belle et la Bête*, and,
in fact, a chestnut-coloured gown with
a fur stole (featuring diamante ears) that
wrapped around the body to form a tail
(see p. 415, left) borrowed its name from
the film; the Associated Press reported
that the soundtrack similarly used snippets
from the movie's score.

Combing through the looks one also notices
the use of tulle inserts on the sides of several
gowns, which give the illusion of endless legs
or some kind of altered anatomy. Yet the key
seems to be in appreciating these couture
creations as one might a sculpture – in the
round. The back of Mariacarla Boscono's LBD
(christened 'Wallis'; see p. 414, bottom right),
and the front of a purple chiffon gown (see
p. 414, left), featured a rib and spine-like
construction. Make no bones about it:
these can be seen as an homage to
Elsa Schiaparelli's skeleton dress of 1938.

Sporty Chic

Jean Paul Gaultier presented a play in two acts this season, opening with a retrospective of looks from his three decades in fashion prior to revealing his latest offering for Spring/Summer 2007. This was introduced over the loudspeakers, reported the *Los Angeles Times*, by the sound of Jane Fonda saying, 'Are you ready to work out?' and suddenly the audience saw models, who had strapped open-toe high-heeled sandals over their high-top sneakers, sweating it out on gold-bedazzled exercise equipment.

Gaultier, a designer with a sense of fun, glammed up the gym. The opening look was a tank dress with lace trim and sheer insets that had a lingerie feeling (see opposite, top). There were striped ripstop trims on silky hoodies and generously proportioned satin 'baseball' jackets with Asian-inspired embroidery, familiar from earlier couture shows. Some looks also featured the number '30' as a reminder of the brand's big anniversary.

There were amusing accessories, like rhinestoned whistle pendants, tiara-visor hybrids and tea-ball earrings (those last recalled Gaultier's earliest collections). The show closed with a series of short, full-skirted frocks in jelly-bean colours, followed by sparkling evening dresses worn under clear-sequinned mesh tops with athletic trim. 'It's a play on sports clothes to turn them into the complete opposite,' the designer told a critic from *The Hamilton Spectator*.

Virgins

He just couldn't resist. The tune that was playing at the close of Jean Paul Gaultier's Spring/Summer 2007 couture collection was Madonna Ciccone's scandalous-in-the-'80s hit, 'Like a Virgin'. This followed a procession of Madonnas (as in, the mother of Jesus) and other heavenly creatures, and a cast that included the burlesque performer Dita Von Teese (see opposite, bottom right and p. 425, left). 'We were looking for a little corner of paradise,' the designer said, knowing full well that the apple had long ago been bitten.

Each of the models wore a unique halo, and some had the appearance of a living icon – a bit of a twist on the dress with a built-in altarpiece that Naomi Campbell wore in the Autumn/Winter 1997 couture collection (see p. 246). Ecclesiastical references, from Irish lace to stained-glass windows, were rife. Jessica Stam wore a floaty chiffon dress in lingerie pink with lace trimming on the hems and centre front in the shape of a chalice (see p. 422, bottom right), and Querelle Jansen wore a blue and red dress with a sword-pierced heart (see opposite, left). One dress (see p. 424) featured a print of a naked woman cavorting with putti in the sky, in the style of painter William-Adolphe Bouguereau, and an example of earthly delights mixing with heavenly ones – which is sort of a couturier's job description, after all.

So British

The Canadian model Coco Rocha opened
Jean Paul Gaultier's 'So British' collection
(see right) by Irish dancing down the runway
in a Beefeater-red double-breasted coat.
(She closed the show the same way, but in
a rainbow-coloured and striped coat dress
paired with a shirt and tie; see p. 429, top
right.) It was an amusing ploy that made
good copy, and added some gloss to a
collection that, as the *Los Angeles Times*
(rightly) concluded, 'was not groundbreaking,
but it was a tartan-covered good time'.
Maybe the designer's passion for a theme
was competing for his ardour for Great Britain.

All the symbols were there: the plaids,
trench coats and uniform jackets of the
establishment, countered by the moto
jackets, cobweb knits and spiked hair
(or, in this case, feathers; see p. 429, bottom
right) of the punks. Yet the latter lacked the
bite, perhaps because Gaultier worked his
materials to such luxurious ends: his argyles
were not knit, but made from knitted fur.

As usual, Gaultier continued working
through themes from the January couture
show (see p. 420) in the ready-to-wear
collection that followed. It's there in the
open-work face coverings, and in material
featuring flaming hearts and putti (see p. 429,
top left). In the centre of punkish knits, the
designer set oval fragments with a depiction
of *La Tempête* (*The Storm*; see p. 428),
a 19th-century French painting by Pierre
Auguste Cot. It shows a lightly dressed man
and woman clinging to each other and holding
a cloth over their heads as they run through
the woods. In this collection, it is these
two who best embody that punk motto,
spelled out on brooches, 'Too fast to live,
too young to die'.

Pirates

Once again it happened at the movies
for Jean Paul Gaultier; his Spring/Summer
2008 ready-to-wear collection was partially
inspired by *Pirates of the Caribbean*. The
third installment in the series was subtitled
'At World's End', which, for fashion folk,
immediately conjures Vivienne Westwood
and Malcolm McLaren's shop at 430 King's
Road, which was the birthplace of punk and
the New Romantics. This happy coincidence
had the result of expanding pirate lore to
make room not only for the swashbuckling
Captain Jack Sparrow, but also for his
predecessor, the dashing Adam Ant, who
took to the charts rather than the sea.

Gaultier's penchant for the Navy or, more
specifically, sailors, is well known, and he
duly showed a *marinière* made of rows of
blue and white nacre buttons. His use of
camouflage referenced a different arm of the
military, the land-based Army. The ceremonial
flourishes of military gear, such as braid,
were put to use on jackets and coats. Other
standard sartorial tropes were repurposed.
Bustiers were constructed from three belts
wrapped around the torso, and trench coats
and motocross jackets featured unexpected
insets of crochet.

Bringing things back to the sea was an
undersea creatures print; the most literal
takes on the pirate theme were tricorn hats,
a dagger-shaped hat pin, hoop earrings
stacked with skeleton beads, and skull-
and-crossbones brooches and belt buckles.
The thirteen brides who closed the show
(see p. 438, right; p. 439) might have been an
allusion to the myth of sailors having a wife
at every port. There was nothing submissive,
however, about Gaultier's strident sirens,
who, in see-through dresses and a nacre
bodysuit, were anything but blushing.

Mermaids

Coming off a pirate-themed ready-to-wear show (see p. 436), Jean Paul Gaultier continued to be submerged in the life aquatic for the Spring/Summer 2008 couture. His show opened with a real-life take on Hans Christian Andersen's 'Little Mermaid' – as she exists in the Copenhagen harbour – with Coco Rocha posed on a rock as soap bubbles wafted in the air (see right).

Yet another myth would be manifested, after a fashion, through this lineup when, a month later, French actress Marion Cotillard wore a look from this collection (see p. 444, left), created by the Frenchiest of couturiers, to accept the Academy Award for her portrayal of the iconic French chanteuse Edith Piaf. Sirens sing sailors to their death, while Cotillard brought to life an artist who drowned her sorrows in alcohol.

This collection was intoxicating in terms of craftsmanship. The second look, a navy coat shown with a *marinière* and mermaid-beaded skirt with a sailor button front (see opposite, left), was a stunning gender- and species-bending creation. Gaultier's main preoccupation here was not tailoring, but explorations of a sea theme. Lettuce-edges on a dress recalled the tendrils of jellyfish, which also appeared as prints (see p. 442, left). Shagreen was as textural and thematic in this context, as was fishnet. References to China and to Greece might be understood in terms of those countries being centres of sea trade. Yet it was scales, shells and shine that were main throughlines here. Models' hair glistened as if it were wet, and a *marinière* minidress was created using alternating strips of Irish lace and blue sequins that glistened like sun on the sea (see opposite, right). Sequins were applied as if they were individual scales, or in scallop patterns. A corset made of gold metal and shells (see p. 444, right) looked like sunken treasure. The closing look, which featured a latex bustier with conical pointed-top shells over the breasts (see p. 445), was a wink-wink reference to the cone bra, one of Gaultier's splashiest signatures.

Magic Donkey

Jean Paul Gaultier adapted the title of his Autumn/Winter 2008–2009 ready-to-wear show from a 17th-century folk tale, 'Peau d'Âne' – 'Donkey Skin' in English, also known as the 'Magic Donkey' – a sort of precursor to 'Cinderella' by the Frenchman Charles Perrault. As the Associated Press wittily put it, the designer 'delved further into fairy tale land in search of the big bad wolf'.

While the mermaid, who inspired the preceding couture line (see p. 440), is a hybrid mammal, in 'Peau d'Âne', the princess dons a repulsive donkey skin as a disguise. In Gaultier's edit, the animal prints and pelts and furs the models take on are meant to be aesthetically appealing. The designer made use of animal prints, leather and three types of fur – farmed, upcycled and faux – and brought attention to that fact by showing a real fox stole as well as a stuffed version. The most dramatic treatment of hides was the over-embroidery of a tattoo/scale-like pattern in white on fur. Two models had the same motif shaved into the back of their short hair, noted Nicole Phelps for Style.com. 'All of this played out as Michael Jackson's "Thriller" mingled on the loudspeakers along with the sound of lambs baaing. Going to the slaughter?' she quipped.

More tame was the designer's use of gems, which might connect to the princess theme in Perrault's story. Whereas crystals mingled with lace in the couture collection, in the ready-to-wear they were applied both to fur and to knitwear. Pearls also were in play – most effectively edging a jersey hoodie (see right), which was paired with a pinstripe pantsuit with bold shoulder flanges.

Cages

Saddlery and Samurai cutwork and crinolines, the Eiffel Tower and eras past: all these elements were present in Jean Paul Gaultier's Autumn/Winter 2008 couture collection. The designer might have stated that his inspirations included *Tron* and the 'fluo kids' from clubland, yet there was a zany element to this show that felt like it had more to do with the slapdash humour of *La Cage aux Folles*. How else to explain the bride wearing a combination headdress/train (see p. 455) that looked like a cage crinoline?

'It's all about construction and foundation,' Gaultier told critic Hilary Alexander. Armour and corsetry are recurring themes in Gaultier's work; here he created open-work cages. Some were mostly visible from the back, and they often appeared at sites known for body control: shoulders, collar, waist, bustle. Gaultier also made use of metal mesh, showing it under an Aran-knit dress kept in a cone shape with the help of a round hoop at the hem (see p. 452, top right and bottom right). In addition to the front/back, hard/soft, over/under dichotomies, there was a lot of neon. It extended down either side of the runway, it peeked out from under the models' bangs, and it made its brazen way into the palette; the effect was to make those highlighter-coloured pieces feel trendy rather than timeless. At the same time, it helped the designer transform his mannequins into exotic birds. 'I have no intention to seriously put women in cages,' Gaultier told *The Daily Telegraph*. 'My models are birds of paradise. They can remove the cages and fly.'

Dance Studio

Back in the day, Jean Paul Gaultier's lengthy shows often included a performance – a tradition that he dusted off for Spring/Summer 2009. The designer, who had just created costumes for choreographer Angelin Preljocaj's take on 'Snow White', returned to that tradition; his presentation opened and closed with performances by a trio of dancers from Emio Greco and Peter Scholten's troupe, whose movements were reflected in the three oversized mirrors, two of them with circus effects, at the end of the runway.

The kind of punk Degas dancer in a tutu and moto who appeared in Gaultier's earliest collection (see p. 26) was nowhere to be found this season. The silhouette here was more fluid and slim, a mix of disco/Stephen Burrows and Jane Fonda in her workout phase, and the vibe was dancer off duty. (The *déshabillé* lingerie looks in the lineup could be seen as a sort of civilian interpretation of that.) As critic Nicole Phelps noted, 'Rehearsal was the designer's ostensible theme.'

The show opened with a series of wrapped *maillots* or dresses in jersey. 'The idea was to create clothes that have several uses. You can go for a swim, you can also go out and it turns into a dress,' noted Gaultier. High-waisted suspendered leggings made an appearance, and fishnet stockings peeked up over waistlines. Reprising one of his '90s tropes, Gaultier showed leotards over suiting. Robes and a lace insert on slip dresses depicting boxers in a ring recalled the sports theme the designer explored on the occasion of his 30th anniversary (see p. 416). Tattoo prints, fur stoles, metal mesh and cage details carried forward elements from the past four years of prêt-à-porter and couture collections. Newer was the twisting technique Gaultier picked up from watching the dancers. If the designer was focused on fiction for his dance collaboration, here the emphasis was on clothes for real life.

Calligraphy

Jean Paul Gaultier never followed a script, but wrote his own story in fashion. As lore had it, when passed up for Christian Dior, he went ahead and started his own couture house. That being said, the designer knows his fashion history, and his 'V' line for the Spring/ Summer 2009 couture could be seen to fit in the tradition of the letter silhouettes ('H', 'Y', etc.) popularized by Monsieur Dior himself. Gaultier, however, has never been able to stick to only one theme and so, added to the strong angles that repeated throughout the lineup, were rounded 'letters' – hourglass silhouettes. 'His conceit', wrote critic Sarah Mower, 'was to take scrolling, curlicued calligraphy and abstract it into fine-lined prints, fishnets, and embroideries, and marry those with the strong-shouldered, sometimes pinstriped tailoring he introduced in the eighties.

On the back screen, an image of a pen-and-ink flourish appeared in motion, going through strange computer-generated distortions. After a while, the penny dropped: It looked like the patterns used on bank notes.' This was at a time when the economy was tanking, yet that wasn't a talking point for Gaultier, the eternal optimist, who told the French press, 'I've been wanting to talk about Klaus Nomi, the '80s, and black and white, but not sad.'

In contrast, the English-language reporters were told a story about 'a gender-bending matador who's not afraid to show a little skin', as the Associated Press wrote and to whom the designer said, 'I've taken the symbol of the macho identity and grafted really feminine elements into it. It's a sort of androgenization.' The whole exercise felt very Cartesian, actually. Models sported square headdresses, some that looked like Wright Brothers' contraptions, and the complicated threadwork on corsets and necklines resembled something you might draw with a spirograph or find on an overhead bridge. True to form, Gaultier demanded a willing suspension of disbelief when it came to couture.

X-Rated

Having flashed 'V' as in victory for the Spring couture (see p. 460), Jean Paul Gaultier moved on down the alphabet, settling on 'X' – pirates' preferred letter – as the main motif in his Autumn/Winter 2009–2010 ready-to-wear collection. The first exit, featuring bondage straps (see right), hinted at X-rated content, and indeed the designer did have sex on his mind. One print featured what looked like American dollar bills, but these were issued by the United States of Gaultier; S-E-X was spelled out on the reverse side of the currency (see opposite, bottom right). One might also hope to rate as an X (as in the Roman numeral ten) an LBD with X-shaped seams at the bust (see p. 466, left) or a sheer inset in the same shape (see p. 466, top right and bottom right). Mesh, the audience was reminded, is a collection of little crosses. The letter X, explained Gaultier, 'is about fetishism, it's about desire, it's about a lot of things'.

What it wasn't, here, was hardboiled, despite the set-as-brothel bar, and the muddy catwalk cat-fight between actor Bojana Panic and model Coco Rocha that was 'broken up' by whip-carrying, flame-haired erotic jeweler and sex educator Betony Vernon (see p. 467, bottom right). 'It was a bit of fashion theater,' wrote critic Nicole Phelps, 'that made everybody forget about the R-word [recession] for a while.'

Movie Stars

Film, more than clubs, fuelled Jean Paul Gaultier's imagination during the first half of the aughts, and his 'Movie Stars' collection for Autumn/Winter 2009–2010 couture was a kind of culmination of that. Film was the designer's first love before he came of age, after all. This costumer of modern films including *The Cook, The Thief, His Wife and Her Lover*, *The Fifth Element* and *Kika*, chose to shine a spotlight (mainly) on Hollywood's Golden Age. He did so quite literally with the finale look (see p. 471, bottom right): onto the white veil that covered the model's very high hairdo were projected the faces of silver-screen stars. More amusing were his own interpretations of films and actresses.

Lara Stone, a Brigitte Bardot lookalike, opened the show to the sound of an MGM medley (see right). A trench dress that was cut to mini-length in front and hit the ground in back (see opposite, top left) was christened 'French Gilda', and 'Barbarella' was the name of a metallic corset-leotard with three-dimensional protrusions that were faceted like diamonds (see opposite, bottom right). Lady Gaga, a kind of Madonna-like figure for millennials, wore the lilac corset romper from this collection, called 'Mae West' (see p. 471, left), when she won the Best New Artist MTV Video Music Award for 'Poker Face'.

One of the hats Gaultier wears is that of fashion's jester. He particularly likes to play with the high/low mix, and this season he presented several pairs of couture salopettes or overalls, one in crocodile (see opposite, bottom left). Their relation to labour might only make sense in the context of 'drag slang', as in 'You better werk.' 'Effets spéciaux' was the witty name used to describe a trompe-l'oeil look, and – showing how far he had come from making jewelry out of tin cans (how Warholian) – his bracelets now resembled mini film reels (see p. 470, left), while some dresses featured 'clips' in the form of pieces of film or trimmings meant to look like film strips. Couture, a showcase for traditional handwork, naturally has elements of the analog as well.

Bad Girls – G Spot

The trompe-l'oeil muscle/sinew print
(see opposite, bottom right) in Jean Paul
Gaultier's Spring/Summer 2010 ready-to-
wear collection repeats a central tenet of
Gaultier's work, the idea of bringing things
out from under, revealing the body, and
modifying it. The effect of mixing innerwear
with the idea of 'bad girls' (the models wore
'tattoos' that spelled out their names, or
'Gaultier') was, as one newspaper had it,
'hip-hop lingerie'.

The designer revisited the corsetry and cone
bras that he is constantly associated with,
and also added to his repertoire, showing
quilted shoulder pads in lingerie silks, as well
as hip and bum extenders. Pregnant model
Jourdan Dunn wore something that looked
like soft baby-bump armour (see p. 474, left).
'Instead of filling oneself with silicone or
collagen, why not try these prostheses, which
can be taken off?' the designer suggested.

Riffing on the many overalls he showed at
couture (see p. 468), Gaultier replaced the
bib with a bra top for ready-to-wear. The
denim looks (see right and opposite) were in
collaboration with Levi's, but the fabric was
distressed and otherwise treated to show the
skin underneath. There was a lot of military
green. Speaking with the Associated Press,
the designer said his wish was to 'return to
the source. I wanted to get away from the
increasing bourgeois understanding of
fashion.' As he explained, 'When I started
there was a real desire to be individualistic
and to mark our difference from one another.'
This makes the idea of a 'girl gang', with which
the show opened, a bit perplexing (as a gang
is a collective with some unifying signifiers).
Unless, that is, you consider this cadre to
be a band of outsiders.

Mexico

As a lonely child, said Jean Paul Gaultier
in a 2010 interview, 'you live in your 'ead'.
This Spring/Summer 2010 collection is proof
that he never got over that habit. It was
an imaginative rendering of Mexico (South
America, really), pieced together from sources
including Mel Gibson's *Apocalypto* (2006),
the British Museum's 2009 exhibition
'Moctezuma: Aztec Ruler' and James
Cameron's *Avatar* (2009). Underlining
the fictional aspect of the lineup, the
presentation – which included a live mariachi
performance – closed with Arielle Dombasle,
'a French icon of renown', noted critic Sarah
Mower, 'lip-synching as Carmen Miranda'
(the song was 'Cucurrucucu Paloma').
Similarly, these honest-to-goodness couture
clothes, made with French savoir-faire,
borrowed elements of *Latinidad* – as in a
rainbow-coloured dress, cut in the round,
and made of delicate chiffon inspired by
Mexican stripes – without replicating them.

The opening look was a *vaquero*-ish suit
composed of a double denim jacket with gold
embroidery and a jean-effect jacquard skirt
worn over a voluminous white skirt (see right).
This was followed by a jacquard-jean jacket
with corset-lacing up the back and side-slit
denim jeans covered in clear sequins (see
opposite, top left and bottom left). A 'jean
dentelle' (denim cut like lace) appeared later in
the lineup (see opposite, right). Students from
the Royal Academy of Fine Arts in Brussels
worked on the show, and their contributions
were credited in the programme.

Like denim, fringed Spanish shawls are a
perennial Gaultier favourite and were here
transformed into garments. An over-beaded
dress with tropical foliage and caravel ships
was a first cousin to one shown in the Spring/
Summer 1998 couture show (see p. 260),
and the opening hat recalled the dimensions
of those from the 'Chic Rabbis' collection
(see p. 190). New for the season was
Gaultier's interest in palm fronds. He used
the real thing, and also conjured them using
pleated taffeta. In one instance (see p. 479,
bottom right), soft green ribbons were woven
together as strips of palm would be.

Voyage, Voyage

Nostalgia increasingly entered into Jean Paul Gaultier's work in the 2010s. By this point the designer had a marvellous archive, and history to work with, and this was evident in the staging and the content of his 'Voyage, Voyage' collection for Autumn/Winter 2010, which was a giant salmagundi.

The invitation, reported Style.com's Nicole Phelps, 'pictured a mixed-up map of the world, with Mexico next to Togo, Morocco abutting India, Russia and Greece side by side, and so on'. This was not just an around-the-world-in-a-day proposition, but a proposal for around-the-world-in-an-outfit dressing. It wasn't only the mash-up of national dress (whether Nordic, Mongolian, Ukrainian, Turkish, African or South American) that Gaultier was interested in here, but how it intersected with ready-to-wear and casual staples that form the wardrobe of contemporary life. So, the side-stripes on luxed-up sweatpants ended in an ethnic embroidery (see p. 482, left), a peacoat was shown with an African wax-print turban (see opposite, bottom left), and a peasant skirt bloomed from under a smoking jacket (see opposite, right). '[T]he general gist – that the world is flat, and how we dress now is an ever-changing series of mash-ups – was pretty spot-on,' Phelps opined. Gaultier also offered a view of street style as it exists beyond the 7th arrondissement, thus expanding on the idea of 'French girl' style and making it more inclusive.

At the close of the show, the whole cast of models joined the musicians representing different musical traditions on steel girders, much like they did at the Mad Max show, and others in the '90s. It was like a picture postcard, with a message that reads: 'We are family'.

Les Parisiennes

It would be difficult to beat the chic of the first look – black trench, turban-wrapped head, fishnets and booties (see right) – in Jean Paul Gaultier's Autumn/Winter 2010–2011 couture show. Here was the Parisienne, triumphant. Here was Gaultier looking in the mirror, but also perhaps back at Yves Saint Laurent's scandalous 1971 show, which in turn looked back to the 1940s. Et voilà, timelessness meets the contemporary.

It's not a big leap from getting at the roots of French elegance to becoming preoccupied with the essential arts of couture, and then continuing on to the body itself. 'It was all about structure, about bringing the bones, the very foundation of what makes a garment, to the surface,' Gaultier said at the time. 'It's about bones, but not in a ghost kind of way – unless we're talking about the ghost of couture.' Two ensembles spoke to this theme directly. There was Look 15, a sheath with attached ribcage (see p. 486, top left), which seemed to nod to Elsa Schiaparelli and Salvador Dalí's skeleton dress of 1938. But this was positively tame next to the actual striptease that Dita Von Teese performed on the catwalk, mid-show: the burlesque star removed sleeves, bodice and skirt to reveal a skeleton built not over a dress but over a skin-coloured corset (see p. 486 right and p. 487, left).

A kind of 'in my beginning is my end' (in the words of T. S. Eliot) aspect was thus added to a collection in which Gaultier also channelled heaven in the form of built-up 'angel' sleeves, as well as in the finale look (see p. 487, bottom right) – a trench-bridal gown worn by a model playing her own wedding march on a matching white violin. The former had a sort of '80s muchness and glamour, and it would seem that the designer was somewhat in that more-is-more frame of mind, given that he sent looks with names like 'Le Gauchisme de Park Avenue' and 'Le Bûcher des Vanités' (Bonfire of the Vanities, the title of the novel that introduced the idea of the 'social X-ray') waltzing down the runway.

Rock'N'Romantic

A punk hairdo does not a singer make – a voice does, and Jean Paul Gaultier invited a very popular one, Beth Ditto (see right and p. 491, bottom right) of indie band Gossip, to join the cast walking his 'Rock'N'Romantic' show. She gave an a cappella performance at the finale, but the models, wearing Joan Jett wigs, sauntered to the recorded sounds of the older, more hard-edged performer.

As might be expected, given Gaultier's proclivities for punk, there were references to that style, but fewer than you might imagine, as the designer was pulled in so many directions. Guests found paper 3D glasses on their seats, all the better to enjoy the brand's dimension-morphing prints of the season, featuring stars and outer-space motifs. Pleating and ribbing were used to replicate a bit of a glitch effect, as this broke up the straight lines of, say, a *marinière*. For the landlocked, there were safari touches; for the playful, bloomers. Fusty rose and palm prints shared space in the collection, as did lace and moulded, armour-like metal worn as bustiers and collars.

Counting Ditto, there were three curve models in the cast. While not exactly a 'win', it was more than was seen elsewhere in the season, and it has precedent dating back to the designer's early shows.

Punk Can-Can

Jean Paul Gaultier, who worked with real-life 'girls'-on-show like Madonna and Kylie Minogue, was also entranced with the French showgirl and, by extension, the Moulin Rouge and the Folies Bergère, where they traditionally performed. Look 23 (see 494, top right) was titled 'La Goulue', after the stage name of 19th-century dancer Louise Weber, known as the 'Queen of Montmartre' (see also p.166). The finale gown was a strapless number of ruched white tulle, its full skirt lined with a print of dancing legs (a repeat performer in Gaultier's repertoire), which had something of the effect of a Busby Berkeley film, especially when it was danced down the runway by a star of the Crazy Horse cabaret, Psykko Tico (see right).

The collection might be described as a tale of two types of 'bad girl': the naughty can-can dancer and the punk. As Tim Blanks reported: 'The invitation safety-pinned a piece of fishnet to a piece of cardboard.' No surprise, moto followed, as did the most amazing cobweb knits, entirely made of beads, sometimes mimicking a snag. They also had worked into their weave a cameo; these were used throughout the collection, which in addition included a neo-classical Joséphine Bonaparte-style dress (see opposite, bottom left).

A living, breathing queen of the cinema lent her talents to this show, which was organized in an old-school manner with models carrying cards with look numbers, each of which was announced with a recording, made by none other than Catherine Deneuve. This was a format Gaultier played with long before he became a couturier. While La Deneuve was on the speakers, Farida Khelfa, one of Gaultier's earliest muses, then at work on a documentary film about her old friend, was back on the runway (see 494, bottom right).

Ageless Bourgeoise

It's only natural that Jean Paul Gaultier would be in a nostalgic mood, having been the subject of Farida Khelfa's documentary, *Jean Paul Gaultier ou les codes bouleversés* (released in January 2011), and deep in preparation for the June opening of a retrospective exhibition at the Museum of Fine Arts in Montreal. His Autumn/Winter ready-to-wear collection – a meditation on the very subject that was the sand which agitated itself into the pearl of his career – was titled 'Ageless Bourgeoise'.

Gaultier didn't only bring back the lady, he also brought back the lady of a certain age, thus taking on another of fashion's taboos (along with size). The designer noticed that in the past, daughters wanted to look like their mothers; now times had changed, and it was the mothers who wanted to look like their daughters. The *comédienne* Valérie Lemercier, then aged 47, opened the show (see right), and the models wore grey and ash-blonde bouffants with ensembles in what appeared to be a 'bon chic, bon genre' mode. The outfits were assemblages of separates, and in old-school style the models removed their outer garments and gloves as they walked, but in most cases, rather than swing a scarf or jacket over the shoulder, they flung it on the floor at the end of the runway.

This celebration of the lady wasn't always abstract; to an American eye, leather and suede sets with centre-front hardware closures seemed to nod to Bonnie Cashin, though there might have been some Hermès references as well. Cardigan jackets trimmed with snaps (rather than braid) came with print linings that matched the accompanying 'blouses', à la Chanel. It turned out that almost all of the prints, which seemed to be worn as separates, were actually jumpsuits, which were paraded out at the end, similarly to how they had been at the Autumn/Winter 2003 couture (see p. 358). They might also have been a kind of extension of the bodysuit idea that Gaultier used when creating some of the costumes for Pedro Almodóvar's 2011 film, *The Skin I Live In*.

Black Swan

Jean Paul Gaultier might love a theme, but he never arrives at it from a single or a straight course. Take his Autumn 2011 couture collection: its 'Black Swan' title and opening soundbite by actor Vincent Cassel (not to mention its tutus and its toe-shoes balanced on cantilevered heels) were borrowed from the hit 2010 film. You would therefore think that the swan inspired the variety of feather-work in the lineup, yet the designer told reporter Jeanne Beker: 'The parrot feather bolero in that museum show [his retrospective in Montreal; see p. 234] really fascinated me. That's why I've got so many feathers in this collection.'

Always a proponent of gender equality, Gaultier took a 'what's good for the goose is good for the gander' approach to design and showed couture looks for men, breaking with tradition. (Further pushing the idea of gender, the bride for the Spring/Summer 2011 couture collection – see p. 492 – had been Andrej Pejic, now Andreja, who would say in a 2011 interview that 'professionally I've left my gender open to artistic interpretation'.) The designer's casting of men was not some token gesture; nearly half of the looks in the Autumn/Winter show were menswear and they were on point, as it were. As Tim Blanks wrote, these 'male dandies were sloe-eyed decadents from a Diaghilev fantasy, in keeping with the ballet theme'. Like the Nutcracker Prince, they came vividly to life, as, Beker reported, '[t]he models marched directly from the catwalk to a venue around the corner for the launch of Gaultier's new men's fragrance, Kokorico' (cock-a-doodle-doo). Each of the menswear looks was given the name of the fragrance – translated into different languages.

Truman Capote's swans would likely have snubbed Gaultier's mostly anti-establishment flock. The presence of men in skirts (particularly the designer's muse of 26 years, Tanel Bedrossiantz, in a swishing, feathered ball number; see p. 502, bottom right) and '90s favourite Eve Salvail, her shaved head revealing her cranial dragon tattoo, sent some reviewers down memory lane. Yet Salvail's meticulously draped gown with cone breasts (see p. 503, left), *bien sur*, was inspired by the Madame Grès exhibition that had recently opened at the Musée Bourdelle. And there was something exciting, modern and very Gaultier about the opening look: a grey-and-white chalk-striped pantsuit worn over a tulle tutu that peeked out from under the jacket (see right). Mylène Farmer, née Gautier, the French *chanteuse*, closed the show in a feathered and trained tutu paired with a moto jacket (see p. 503, top right), which winked at Gaultier's first-ever hit, bar(re) none.

Tattoo

'Tattoo' has more than one meaning, and
Jean Paul Gaultier played with all of them
for his Spring/Summer 2012 collection, which
contained direct references to his Spring/
Summer 1994 collection of almost exactly the
same name ('Tattoos'; see p. 198); specifically,
'inked' mesh, leather, tights and facial jewelry.
The show not only tapped into the designer's
aesthetic signatures by using favourite
showmanship tricks; it might also be seen
as a riff on the military tattoo, 'an outdoor
military exercise given by troops as evening
entertainment'. Sure, it was held indoors, but
Gaultier has always taken joy in challenging
boundaries, including between good and
bad taste, innerwear and outerwear, etc.

He once again leaned on the old-culture
tradition of number cards and an announcer,
this time enlisting French weather presenter
Charlotte Le Bon for the honours. *WWD*
reported that 'models dressed in full view of
the audience on a two-story scaffold' (that
skeleton-like structure the designer made so
much use of in the 1990s) and, '[a]s a bonus
attraction, photographer Miles Aldridge shot
the designer's spring-summer advertising
campaign live in a makeshift studio set up
midrunway'. (For Autumn/Winter 1996 –
see p. 228 – there had been a Steven Meisel
lookalike 'shooting' the show in real time.)

The collection's main themes were navy
and white, sailor touches, and trenches, all
combined with draping. The finale featured
the models in their lingerie – a familiar trope,
but still one arousing attention in 2011, a
time when the designer felt that fashion was
returning to a sense of propriety. Perhaps
we can think of this collection as a sartorial
tattoo, drumming all things bourgeois away.

Tribute to Amy Winehouse

The movie *Grease* and rockabilly style were among the themes Jean Paul Gaultier explored again and again in his earlier collections, so it's no surprise that he would find a sense of connection with Amy Winehouse's style. 'Her look was incredible – with her sailor tattoos and clothes she was so Gaultier!' said the designer in a magazine interview in the fall-out from his tribute show to the singer for Spring/Summer 2012 couture, which was slammed as being in 'bad taste' by her father. *The Independent's* review ran with the headline 'No, no, no! Jean Paul Gaultier's tribute to Amy Winehouse hits all the wrong notes', but there were other points of view as well. Tim Blanks wrote: 'Amy Winehouse might be a hard act to follow musically, but her personal style was so cartoon-graphic that it loans itself easily to carbon copies. Jean Paul Gaultier proved as much today with his latest show. The beehive, the eye makeup, the beauty spot, the clothes with their tarty fifties flavor, like the gang leader's girlfriend in a teens-running-wild exploitation pic – all these were present and incorrect on Gaultier's couture catwalk. Yet, unlikely as the union may seem, Gaultier managed to turn his couture presentation into both a celebratory send-off for Winehouse and a colorful addition to his gallery of beautiful oddities.'

If Winehouse-isms acted as the recurring chorus of the collection, the verses included many standard Gaultier-isms, though the presence of a barbershop quartet performing 'Rehab' live warped the sense of proportion. The eerily evocative hair and makeup looks also contributed to this. And yes, there was the singer's favourite Fred Perry shirt, made with couture techniques. The one opening the show (see right) was made of jersey pleated in the style of Madame Grès; there was also a backwards polo-style dress later in the lineup (see opposite, bottom left and bottom right). The singer's favoured pencil skirts made appearances, too, among the pinstripes and corsets and gowns that are to be expected in any Gaultier collection.

The parade of models at the finale, many in their underwear, was a repeat of the close of the Spring/Summer 2012 ready-to-wear collection (see p. 504), although these mannequins wore veils. 'I didn't want a funeral,' the designer told *Le Monde*, 'so I brought out a few brides in white.' In conversation with reporter Jeanne Beker, he celebrated Winehouse, who had died six months earlier: 'She had such original style, the way she mixed things up. She was never afraid to try anything.'

Graffiti Couture

The title – 'Graffiti Couture' – of Jean Paul Gaultier's Autumn/Winter 2012–2013 ready-to-wear show signalled a coming together of high and low culture, as it has traditionally been defined. The contrast between the elite and the street is one of the central motivators of the designer's work. And though he has often taken art movements, such as Constructivism and Surrealism, as starting points, he has always made a distinction between fashion and art, saying: 'I am not an artist, I am an artisan.'

Unlike the couture, which is handmade to order, the ready-to-wear is industrially produced – in multiples, a concept that Andy Warhol championed. Gaultier took Warhol, New York, and more broadly the car culture of America, as his themes this season. As Nicole Phelps reported, 'There was a Silver Factory foil paper backdrop, and the Velvet Underground and Nico played on the speakers.' The first look out was a shrunken motocross jacket (see opposite, top left), and there was a photoprint with an automotive theme; the final exit, including a skirt made of upcycled leather jackets (see p. 515, right), had crumpled volumes that recalled the French sculptor César's compressed-car creations.

The metallic sheen of the set was matched by pieces made of cloth that looked like molten metal. Moreover, a silver graffiti print, in the style you might have seen on the side of a New York City subway car in the '70s or early '80s, had been reworked into an incredibly luxe jacquard; there were lush furs as well. Both are markers of an 'uptown' sensibility and pocketbook. It's not surprising that Gaultier would be inspired by 'street' art, especially of a kind that functions like an environmental tattoo, the tagging of buildings being somewhat akin to the inking of skin.

The designer's concluding look back was rather specific: the outerwear pieces that draped up into jackets or coats, or could be let down to become skirts, recall those he presented for Autumn/Winter 1991 (see p. 166). They made for a good encore.

Confession of a Child of the Century

As 'Confession of a Child of the Century' is the title of an 1836 novel written by the French poet Alfred de Musset, and some of the looks in Jean Paul Gaultier's Autumn/Winter 2012 couture collection were named for characters in Marcel Proust's *Remembrance of Things Past*, one might guess that this collection (which borrows its title from the first book) was inspired by literature. *Mais, non.* The designer had started with a filmic reference, Fritz Lang's 1927 *Metropolis*, but then, as a member of the Cannes Film Festival jury, he saw a screening of the movie inspired by de Musset's book starring Charlotte Gainsbourg as George Sand and Pete Doherty as the poet. Wowed by the Libertines' frontman – 'my god he is so seductive, a decadent dandy', Gaultier enthused backstage – he partly changed course.

Erin O'Connor in a black suit and top hat, with rolled umbrella, opened as the masculine-dressing Sand (see right). Dandified female models were joined on the runway by a good number of their male counterparts. If the 'foreigner' was more in the tradition of Beau Brummell, the latter seemed to have wandered off the set of a film staged during the days of 'the Raj'. Some of the models sported corsets as well. As the show progressed, so did the chronology: the looks got more modernist. One corset and pants set had a cubist feeling (see opposite, bottom right), and there were flapper looks as well as Deco motifs, which commingled with a sort of retro sci-fi vibe.

When Gaultier presented his Spring/Summer 1995 'Fin de Siècle' ready-to-wear show (see p. 212), his focus was mainly on fashion history; here, the levels of separation were greater, as the references to garments were also filtered through literature, cinema, gender, and the designer's own body of work. Some critics mentioned the passing of time as being a theme, and it would make sense that that would have been on the designer's mind, as he had recently celebrated his 60th birthday. *The Independent* noted at the time that Gaultier 'is the last couturier left working in Paris who trained in the traditional manner'. This collection, which closed with – wink, wink – a backwards tail jacket over a skirt (see 519, right and bottom left), was a celebration of that French savoir-faire.

Lookalike

At the opening of Jean Paul Gaultier's Spring/Summer 2013 show, strobes lit up a two-storey set of scaffolding on which figures appeared in silhouette in the pose Grace Jones adopted on the cover of her *Island Life* album, as immortalized by photographer Jean-Paul Goude. Model Sessilee Lopez sported a version of the singer's geometric *Nightclubbing*-era haircut as she made the first exit, in what might be described as a cubist smoking that featured a perfectly engineered slash across the chest (see right). A similar treatment was given to a pinstriped pantsuit worn by Hannelore Knuts as Annie Lennox (see opposite, bottom right).

Up next, lookalikes included Madonna in her 'Like a Virgin' incarnation, Boy George, Jane Birkin, Michael Jackson, Sade and ABBA. More convincing as a costume parade than as a reflection of the times, this show highlighted the designer's long association, and affiliation, with music. Gaultier dressed the American group The Manhattan Transfer in 1979, which pre-dates his famous collaboration with Madonna and the release of his own single. Many of his celebrity castings involved musicians, too, from the accordionist Yvette Horner to Beth Ditto. In the audience at the Spring/Summer 2013 presentation was a KISS tribute band, and on the runway (sporting a Debbie Harry-like coif) the French singer Amanda Lear.

The show was a celebration of self-invention and character-building. It's not just with lyrics and sounds that musicians enthral us, but with the personas they adopt. While most of us will never sell out stadiums, our closets are likely to contain one or two garments that make us feel like rock stars.

Indian Gypsies

According to an Associated Press report, guests attending Jean Paul Gaultier's Spring/ Summer 2013 couture show were 'seated in rows named after Indian foods'. The collection itself was a sort of fusion cuisine that brought together elements from East and West, without fully committing to either.

The opening stripes, but not *à la marinière*, were constructed using an elaborate Madame Grès-like pleating technique, and folds were played off of more bohemian touches like fringed backpacks and trompe-l'oeil denim throughout the collection. Gaultier revisited his famously popular long, flounced skirts; this time around they were constructed of a patchwork of sari fabrics (see opposite, right), a sort of sartorial equivalent, perhaps, of the Hindi version of 'La Vie en Rose' playing on the soundtrack. Look 35 featured a toile de Jouy pattern with an Indian theme that was printed on reptile and cut into squares or 'scales', as the show notes had it, which were then individually tacked one-by-one to a dress, puzzle-style.

The waist-accentuating silhouettes of the suits and corsets peppered into the collection were Western. There were allusions to ancient cultures as well; metalwork on black fabric looked vaguely Egyptian, and a dress in total purple, called the 'Nirvana' (see p. 526, right), consisted of two rectangles of fabric that were suspended from the shoulders in a chiton-like manner. For the finale, actress and model Marie Meyer appeared wearing a rattle-like necklace and a criss-cross backpack-top hybrid containing a bindi-ed Indian babydoll (see p. 527). She lifted her elaborate hooped skirt to reveal four young Indian girls who, smiling, ran down the runway. This bit of theatre recalled, for some, the appearance of Mother Ginger in *The Nutcracker* ballet.

Bohemian Warrior

During this period – several years before Jean Paul Gaultier stopped his ready-to-wear line, and after his 35-year retrospective had opened – it felt like the designer was remastering some of his greatest hits: 'Bohemian Warrior' was a case in point. The show opened with armour-like pieces that were convertible via their snap construction (see right and opposite, bottom left and right), and which echoed shapes first seen back in the Spring/Summer 1996 'Cyberhippie' collection (see p. 222). The tin can bracelets from very early days were back as well (see p. 530, top left). *Minaudières* took the form of closed tin cans, and the stripes on a luxurious textile mimicked the indentations typical of such containers. Also familiar from couture collections past were elaborate patchworks, some floating on a sheer ground, which is quite a phenomenal proposition for prêt-à-porter.

It wasn't really clear how the belts-cum-skirts and moll-friendly furs fit into the warrior theme, apart from the fact that they were fierce. A clue to the theme was offered in the collection's two signature prints, one featuring silhouettes of dancers (also used for the set), the other featuring the spelling out of 'Gaultier' in a Deco font.

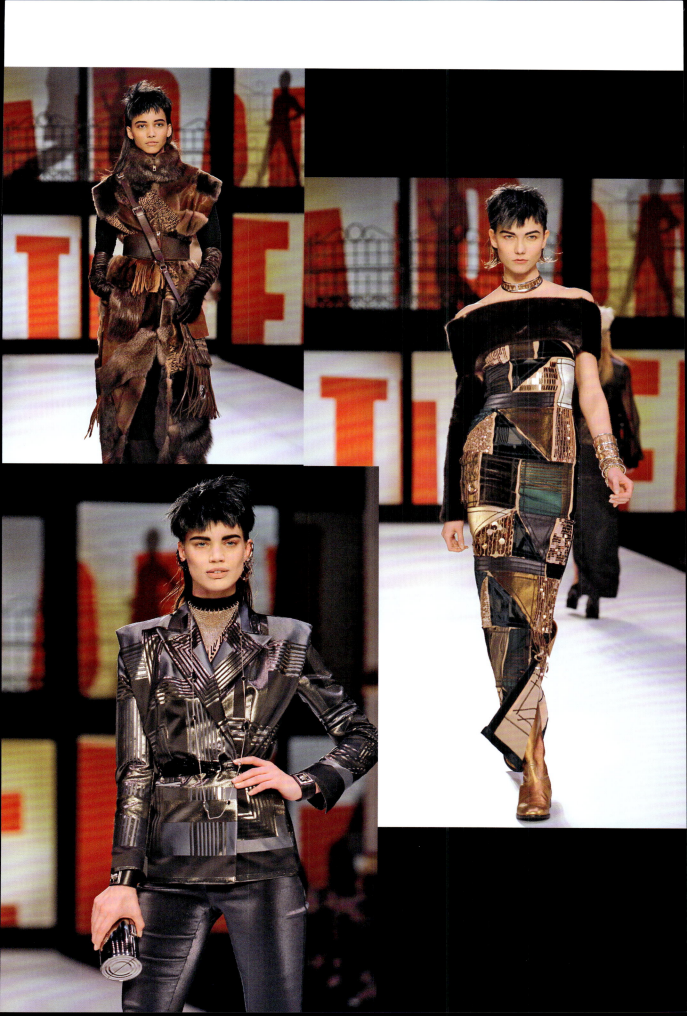

Ashes to Ashes

You might say that Jean Paul Gaultier was 'feline' fine at his Autumn/Winter 2013–2014 couture show. Seat sections took their names from big cats, and the theme of the original madcap *Pink Panther* was on the soundtrack as models, some clawing the air, hit the runway. Many sported leopard spots that had either been painted onto their hair or rendered through prints, beading, or in the case of Look 10 (see opposite, top right), feathers.

Notable in terms of silhouette were the dramatic '80s outlines, including pants shaped like an inverted triangle with flanged 'ice cream cone' pockets. One pair, in jewel-toned velvet, was teamed with a beaded jacket that seemed to nod to '80s Yves Saint Laurent (see p. 534, right), much as a series of padded jackets (see opposite, top left) could have referenced Charles James's famous down topper of 1937. Bringing things up to date was the casting of the reality TV star Nabilla Benattia (see p. 535).

'It's all cinema, it's all from film,' Gaultier told the Associated Press, yet it would be more accurate to say film and music, as the garments were named not only after film characters and movie titles, but songs and singers as well. One had the moniker 'Klaus Nomi'. The pointed caps were inspired by David Bowie's clown persona in 'Ashes to Ashes'. Gaultier, however, being a master of the remix, quoted no references directly.

Let's Dance with the Stars

Switching his attention from the big screen (see p. 468) to the small one, Jean Paul Gaultier's Spring/Summer 2014 collection was inspired by the popular television franchise *Dancing with the Stars*, and it was Gaultier's idea to re-create the casting from the show. At the end of the catwalk sat three judges – Rossy de Palma, Tanel Bedrossiantz and the choreographer Blanca Li – who held up cards in various languages indicating their pleasure or lack of it.

Apart from Look 12 (see opposite, bottom left), a tulle skirt and leather jacket combo that echoed the designer's very first hit (see p. 26), the relationship of the clothes to the theme was unclear, despite the inclusion of 'Snake Dance' and 'It Takes Two to Tango' motifs. More prevalent were photoprints of candy-like Murano glass beads and pins with colourful plastic tops, and a splatter print that was part Memphis/part school notebook. Along the way there were pastiches – *Grease*, dance hall, Amy Winehouse, and the designer himself in a T-shirt that read 'L'enfant Terrible' – but the dancing was authentic and real.

Butterflies

Jean Paul Gaultier turned lepidopterist in 2014 when he presented a couture show that took all things butterfly as one of its main themes – and certainly the most literal one, especially when the designer exploited the wing shape of these fluttering insects. He also made use of their colourful patterns, silhouettes and iridescence; and he even, as Hamish Bowles noted, ventured further afield by using mesh, a play on the nets for catching butterflies (and one of the house specialities).

The casting of the burlesque performer Dita Von Teese, who appeared, almost in costume, as a corseted butterfly (see p. 543), introduced the second theme: Parisian showgirls. Gaultier dubbed this troupe the 'Papillons de Paris' (Butterflies of Paris), declaring that 'By night, she becomes a showgirl!' And so we land on the theme of transformation, aka fashion's superpower.

Rosbifs in Space

'Rosbifs [French slang for the Brits] in Space', Jean Paul Gaultier's Autumn/Winter 2014–2015 ready-to-wear show, could be seen as a *Grease*-style love story – one that unexpectedly brought together two of the designer's earliest influences. Those would be space, a holdover from his days at Pierre Cardin, and British punks, whose plaids, spiked hair, torn fishnets, and destroyed and pinned-back-together clothes Gaultier returns to again and again. This season he flew the flag for Great Britain, rendering the Union Jack in zip-off leather jackets, and sending some of his models down the runway in crowns. He catapulted others into space in outfits complete with neck cones (which hark back to the Autumn/Winter 1987 collection; see p. 118), silver metallics, and X-ray prints of zips and technological folderol. Within the Gaultier galaxy, this unconventional pairing made some sort of sense.

Presented on an aeroplane aisle-like set in the 'Oscar Niemeyer-designed former home of the French Communist Party', Suzy Menkes reported, the show opened with the following announcement: 'Fasten your seat belts, turn off your phones and – French – stop smoking.' JPG Airlines – with Rihanna and Beth Ditto aboard – was ready for take-off, as well as spin-offs of some of the designer's favourite themes.

Vampires

Even when he takes a walk on the dark side, as he did with his 'Vampires' show for Autumn/Winter 2014, it's difficult to imagine the ebullient Jean Paul Gaultier ever squaring with The Smiths' 'I wear black on the outside 'cause black is how I feel on the inside' mantra. That inky hue predominated, but so did a few others. The designer described them to Hamish Bowles as 'blood red, virginal white, black Sabbath, the silver of a knife, and the gold of religion'. Gaultier's other references tended rather toward the unholy: Scarlett Cannon, 'the alarming keeper of the door on the London club scene in the early eighties' and Maleficent, played by Angelina Jolie, which the Associated Press suggested was another of the designer's touchstones.

As always, there were some truly elegant looks, like 'Danse Macabre', a black velvet and ivory crepe sheath with spiked 'bandoliers' (see p. 550, left), and 'Mommy Dearest', whose mystery was revealed when the model in a column of velvet turned to reveal a deeply scooped back trimmed with sea pearls (see p. 551 left and bottom right). Gaultier, who had been playing with chains for a few seasons, presented a hoop-skirted dress with lookalike lamé links (see p. 552), and a tour-de-force suit whose pinstripes were silver chains caught on organza that extended past the cuffs to form fringe (see right). These shared space with thong-exposing and sporty looks that remain unexpected in a couture offering.

'Vampires' might be thematically related to the designer's 'Sleepy Hollow' show of Autumn/Winter 2006 (see p. 408), but it was far less moody or spooky, concluding with an angel bride (see p. 553, right). In fact, it was largely an exercise in camp. This was hinted at by the names of some of the garments ('Morticcia', 'Doriane Gray', 'Batgirl', 'Fantomette' [sic]) and confirmed by the show's penultimate look (see p. 553, left), which was worn by the self-styled 'drag artist' and 2014 Eurovision winner, Thomas Neuwirth, aka Conchita Wurst, aka the Bearded Lady. As Gaultier told *The Independent's* Alexander Fury: 'I can't talk for others and I never did something just to provoke, but I wanted to show different beauties and personalities on the runway when I started. And I still do.'

Miss Jean Paul Gaultier

Having decided with Puig, the luxury conglomerate that acquired a majority stake in his company in 2011, to focus on couture, fragrances and other creative projects, Jean Paul Gaultier devised a magnificent spectacle for his final ready-to-wear show at Le Grand Rex in Paris. The red-white-and-blue sashes sent as invitations hinted at the beauty contest theme. The audience, snacking on popcorn and sipping champagne, sat rapt as Rossy de Palma, who appeared to the strains of RuPaul's 'Supermodel', took on the role of 'Madame de Fontenay, the behatted former chairwoman of the Miss France committee', as Nicole Phelps reported, and was joined in the role of emcee by the journalist Alex Taylor.

What followed was a show in several acts, including: Miss Tour de France (models in sporty-themed clothes printed 'Loco Logo', preceded by men on bikes; see p. 556, top); Miss Femme de Footballeur (models in denim and bandanas, chewing gum and taking selfies; see p. 556, bottom); Miss Vintage (mature models escorted by shirtless hunks); Miss Lucha Libre (models in Mexican wrestling masks and uniforms; see p. 557, bottom); Miss Smoking. There was even a Miss Rédactrice de Mode (fashion editor) section (see pp. 558–559), in which models were made up to look like six women who had supported Gaultier throughout his career: Grace Coddington, Babeth Djian, Emmanuelle Alt, Franca Sozzani, Carine Roitfeld and Suzy Menkes. Mixed in among these were pinstripe suits and corsetry and cone bras. Having opened with a Busby Berkeley-like number in which a group of dancers wearing *marinières* and sashes performed on the set's tiered steps (see right), the show concluded with a gathering of all of the Miss groups, and finally the crowning. Upon winning the prize, model Coco Rocha fainted, and Anna Cleveland attempted to steal the crown. That, of course, belonged to Monsieur Gaultier, who ambled down the stage in a sash that read, what else, 'Miss L'Enfant Terrible'.

Just as 'terrible' has two meanings (it can be used to describe something awful, or else to emphasize, as in 'something was terribly grand'), so too does 'miss' (this can be used as a female title or to indicate the lack of something). But this finale was not so bitter as sweet, since Gaultier was not putting down his needle, but rather, as he told *Le Temps*, passing on the flame. 'Do I look sad?' he asked. 'No way! I've always dreamed of showing at Le Grand Rex! And here we are! It's wonderful. And anyway it's only goodbye for now. So let's give way to young people in ready-to-wear. There are some who are making things that aren't too bad at all!'

61 Ways to Say Yes

Having presented his final ready-to-wear collection in September 2014 (see p. 554), Jean Paul Gaultier celebrated new beginnings, and perhaps his renewed commitment to couture, with a marriage-themed show aimed at what critic Nicole Phelps dubbed the 'alterna-bride'. The tongue-in-cheekness of it all was emphasized by the soundtrack: Billy Idol's 'White Wedding'.

White is a symbol of purity and often virginity; but there was a snake (representing sin) in this garden, literally. It came in the form of reptile. There was the real stuff, a printed version, and also simulations of the scales and colour gradients wonderfully rendered in beads. As *The Guardian* noted, 'the technical details are staggering and the humour levels are high'. (This is true of Gaultier's work in general.) An example of the latter is an overall-style gown accessorized with a beekeeper's hat, named... mic drop... 'Honeymoon' (see p. 564, top right). 'This is the bouquet: Packaging of beauty' read the show notes for the finale look, worn by Naomi Campbell dressed as a posy.

Gaultier had similarly used greenery for his Spring/Summer 2002 bride (see p. 332), and there were many references from that collection and from Spring/Summer 2001 couture (see p. 318) in this one. The opening look, a bridal gown of silk tulle accessorized with a conical coif complete with hair rollers and a husband-and-wife statuette (see right), also seemed to nod to an actual confectionery headdress worn by Anna Pawlowski in Autumn/Winter 1980–1981 (see p. 47, right). It was an eat-your-cake-and-have-it-too couture moment.

Paris–Brest

With his 'Paris–Brest' collection for
Autumn/Winter 2015–2016, Jean Paul Gaultier
reinforced his position not only as the most
Parisian couturier, but also as the most
French, notably doubling down on the Breton
stripes that are the most potent symbol
attached to his *maison*.

Rather than take another trip around
the world, Gaultier instead circled back
in history – his own, and that of Brittany.
The programme note was written in Breton
(according to the government's Explore
France website, 'Brittany is one of the six
official Celtic nations of the world') and
French, and the circle motifs throughout
were variously interpreted as 'pancakes'
(*The New York Times*) and 'Celtic Circles'
(the Associated Press).

The critics' favourite seemed to have
been Look 44, called 'Plume-Plume Tralala',
featuring a trench coat made of rooster and
pheasant feathers (see p. 569, top left), yet
more on-theme were beautiful embroideries
inspired by the seaside region's local
handwork, which also informed the
tall headdresses.

Guests enjoyed an immersive experience:
crepe-makers were busy making treats,
and the Bagad Pariz – Ti Ar Vretoned Breton
bagpipe band performed. *Vogue* reported that
'[a] foghorn and the sound of gulls marked the
start of the show'; *The New York Times* noted
that the music playing for Gaultier's bow was
'In the Navy' by the Village People.

Le Palace

The asymmetric pyjama suit that opened Jean Paul Gaultier's Spring/Summer 2016 show (see right) had a loucheness that Hugh Hefner might have appreciated, yet this was a show dedicated to the Parisian nightlife of the '80s that revolved around the legendary Le Palace nightclub – a playground for rock stars, designers and *le bon ton*, which, reported the Associated Press, was inaugurated 'in 1978 by Grace Jones, who famously serenaded the guests with her version of "La Vie en Rose"' while astride a pink Harley-Davidson. Gaultier spent a lot of time there, and he first made his mark by translating what he saw on the street and out on the town for the prêt-à-porter runways. The designer dedicated the show to the French punk Edwige Belmore, who had died months before, and who had reigned over the door at Le Palace as well as serving as an early model and muse.

Gaultier also referenced other style and cultural icons from that era, such as Farida Khelfa, Grace Jones, David Bowie and Debbie Harry, in a collection that played with loungewear, androgyny, glamour and punk. Models wore studded winklepickers and razor and paperclip earrings. It wouldn't be a Gaultier show without pinstripes; Look 17 combined them with a jabot gathering at centre front, as if a lover had grabbed you by the jacket and pulled you close (see opposite, right). Elsewhere a jogger-style suit was paired with a cropped tank and boxer-like shorts (see opposite, bottom left). As the Beastie Boys said: 'You gotta fight for your right to paaaarty.'

Also in the mix were jumpsuits, as well as (embroidered) jeans, still a rather taboo couture statement. What looked like bleached denim was a jacquard (see p. 572, bottom left), and the 'lace' on a printed slip dress (see p. 573, bottom left) was unexpectedly made of leather. Sweet dreams – and disco nights – are made of this kind of chic.

Woods and Forests

'I Love the Nightlife' seems more like Jean Paul Gaultier's theme song than 'A Forest', yet the designer went hiking for his Autumn/Winter 2016–2017 couture collection. Using an autumnal palette, Gaultier made use of fabrics with wood or photographic nature prints, as well as a birch forest jacquard. The designer had some of his models open their coats to reveal linings that matched their dresses, and in so doing created a kind of panoramic nature view. Even more theatrical were the elaborate halos worn by many of the models.

Those coifs, and the angelic bride (see p. 579, bottom right), had an otherworldly effect, but Gaultier otherwise dug deep into his theme, adding marquetry details: given the concept, the wavy pattern of moiré read as woodgrain, while 3D embroidery 'en relief' and ribbon-work supplied textures that mimicked bark and lichen. An outdoorsy vibe was evoked by lumberjack plaids, rendered in mohair or tulle. A black ensemble, with a leather top, borrowed details from warm toggle coats (see p. 576, bottom right), and the rugged Canadienne shirt-jacket got an haute makeover. Look 8, a leather suit featuring whipstitched seams and an intricately braided skirt (see p. 576, top left), seemed to reference Gaultier's Hermès days, while a coat embellished with buttons (p. 576, top right) and a floor-length safety-orange mohair sweater coat utilized techniques and silhouettes from Gaultier's Spring/Summer 2003 and Autumn/Winter 2002 couture collections, respectively (see pp. 350 and 340).

Countryside Beauties

Although he was dreaming of Mediterranean beaches, fields of flowers, and the good old country life, Jean Paul Gaultier opened his 'Countryside Beauties' ('Belle des champs', in French) show with looks that meant business, and that situated what the escapism was from. 'Out of Office' was the name the designer gave to a banker's suit worn with a hibiscus-printed blouse and a headscarf. A navy and white 'pinstriped' suit was constructed of blue ribbons and ivory soutache (see opposite, top right). (Gaultier has iterated as much with pinstripes as he has with Breton stripes.) It wasn't the only visual subterfuge: this season, his 'jeans' looks were made using strips of faded ribbon. In Look 8 (see opposite, bottom left and bottom right), these were used for a wide-shouldered jacket that nipped in the waist.

The Associated Press opined that this collection was 'all about 1980s' excess'. That was certainly the focus of the 'Le Palace' show (see p. 570); here, such a message was less clear, the names of the exits also referring to weather and balconies and bikinis – more of a resort mood. Imagine being office-bound and flipping through travel brochures and fantasizing about the places you might go; it was that kind of vibe. Note the luscious, to-the-floor, sleeveless cabans ('summer peacoats'), as in Look 25.

'Sculpture' was a word that increasingly featured in Gaultier's show notes, and one of the most dramatic ways it was used was for Look 18 (see p. 582, bottom left), featuring a jacket described as 'Irish guipure sculpture dotted with real silver leaves, shoulders anamorphosed with accordion ribbon'. One of the last looks (see p. 582, right) featured a round sleeve, or 'sculpted sun'. The bride (see p. 583), who was pushed part of the way down the runway in a hay-filled wheelbarrow by a shirtless hunk in overalls, sported two of these 'suns' – so big they looked more like wings. Perfect, then, for a midsummer night's dream.

Ice Queen

Rather than embark on a world tour for Autumn/Winter 2017, Jean Paul Gaultier focused on trans-continental drift. His twin preoccupations for the season are summed up by Looks 59 and 60. The former, a long embroidered velvet dress glistening with 'falling pearl flakes' depicts a snowscape at the Grand Palais (see p. 586, right); the latter, called 'Indian Winter', provides, as the show notes read, 'a rare view' of that phenomenon, on a dress featuring zebras and ostrich feathers (see p. 587). '[It's] childish and exotic. What was funny was a mix of winter. So the snow, and the pullover. And also the saree, which is from a country where there's a lot of sun,' the designer explained to the Associated Press. 'It snows in India, too,' he told *WWD*.

The face jewelry worn by some of the models harked back to Gaultier's boundary-pushing Spring/Summer 1994 ready-to-wear show (see p. 198). Furry Russian chapka hats accessorized Aran and 'Scandi knit' sweaters, which were also prevalent in his early work. One of those fisherman knits (see opposite, top right) was here embroidered with pearl beading and had a 'gilt mink lining' – nothing rustic about that. There was a Norwegian-style sweater made of chain mail (see opposite, bottom right), and a fringed version (see opposite, left; described in the show notes as 'a Christmas sweater dress') was embroidered with precious stones. Gaultier's couture take on a puffer included the addition of silver rooster feathers. Who but Gaultier would combine ski and sari chic? Coco Rocha closed the show pedalling a cycle rickshaw down the runway. The finale soundtrack? 'Let It Go', the hit song from the movie *Frozen*, in French.

Tribute to Pierre Cardin

Once upon a time Pierre Cardin took a chance
on an 18-year-old autodidact named Jean
Paul Gaultier, and history unfurled from there.
The Spring/Summer 2018 couture found the
designer (nominally) circling back to his start
with a show called 'Tribute to Pierre Cardin',
which was attended by the then 95-year-old
designer. The first look, a striped black and
white dress made of curved pieces of fabric,
worn with a bowl-cut wig, a neckpiece and
mismatched hosiery (see right), had a *Who
Are You, Polly Maggoo?* and *Blow-Up* vibes.
Ditto Look 44, 'Cardinella'; but, apart from
that, this collection was largely an unravelling
or exploration of all things round and twisting.

There were coil-meets-sari dresses that
wrapped around the body like ribbons: Look
32 was described as a 'peel of asymmetrical
black satin'. There were also optic ball
prints, with psychedelic or hypnotic powers
(according to the show notes). A sharp suit
with inset twists (see opposite, top left) was
described as 'kinetic', but what really got
things moving were the metres of fringe used
throughout the show. Sometimes this was
wondrously controlled, the strands creating
a beautiful texture; sometimes there was a
control-and-release effect, with the fringe
falling free at the hem, as with a dress
made of ribbons (see opposite, top right).
Free-flying fringe is a trim – and maybe even
a gestural attitude – less associated with the
Mod early '60s that were defined by Cardin,
and more with the hippie era that followed.
Ditto denim, which Gaultier offered in a
trompe-l'oeil version made of soutache in one
case (see opposite, bottom left), and minute
beads in another. It seems the designer was
chasing a sense of liberation, as he told the
AFP international wire service: 'We are at
a moment where there's a lot of marketing
in fashion; it's really the thing that takes
precedence. It's made me think of the
time when I started – there was this kind
of creative freedom, a joyful time, too,
where there was creativity, particularly
chez Monsieur Cardin.'

Cardin's verdict? 'It was creative, but
quite theatrical all the same. That's the will
of Gaultier, his personality. He is an artist.
I am very proud for him,' he told the
Associated Press.

Smoking, No Smoking

No designer loves word play more than Jean Paul Gaultier, and he had fun with the double-entendres for his 'Smoking, No Smoking' collection, which played on the French for tuxedo ('*le smoking*'; a Gaultier signature) as well as the introduction of a partial smoking ban in Paris, effective July 2018.

Marlene Dietrich (for whom a trompe-l'oeil dress was named in this collection) turned heads when she wore a tuxedo in the 1930s. The idea was still taboo in the 1970s, when Yves Saint Laurent introduced *le smoking*. What could possibly be shocking in 2018? Well, men on a couture runway, for starters, and nipples. The penultimate look was a couple, their naked torsos covered by clear plastic 'screen bustiers' advocating, in French and English, for the liberation (on social media) of those body parts. It seems that imposed restrictions still make Gaultier, a Frenchman who champions *liberté* and *égalité*, smoking mad.

There were unending variations on black and white and tuxedo dressing, including one 'penguin suit' that could be folded into a waist pouch (see opposite, top right). The act of smoking was in play, too: there were 'white plume boas representing plumes of smoke', wrote the Associated Press, and the bride's semi-transparent grey dress resembled a puff of it (see p. 595). A trench was made of the same material, as were rectangular slip-on sleeves (see p. 594, bottom right), perhaps a continuation of the 'sun' shoulders from Spring/Summer 2017 (see p. 580).

The designer, now in his archive stage, included several '80s references: he asked Stephen Jones to recreate his famous fez hats (see p. 78), one with fringe coming out of the eye holes (see opposite, top left), and there was a 'Boy Toy' belt (an '80s Madonna reference). A soutache 'script' dress nodded to Autumn/Winter 2000. There was also a ruffled showgirl dress (see p. 594, left), and some beautiful beaded Scandi-sweater looks, but for the most part Gaultier wasn't 'bumming cigarettes' but sticking to his own full pack. As Vogue Runway's Nicole Phelps concluded, 'This was a collection about tailoring and its versatility across genders.'

Game of Pleats

With the benefit of time, we know that Jean Paul Gaultier's Spring/Summer 2019 couture show was his third to last – equivalent to the x of the alphabet's final trio x, y, z. The designer revived this shape, to which he had previously devoted an entire collection for Autumn/Winter 2009 ready-to-wear (see p. 464) after designing tour costumes for Kylie Minogue's tenth album, X, in 2007. X is also the shape of mesh – a material Gaultier returned to again and again, even using fishing net in his earliest collections – and he set out to sea again, opening the show with a floaty *marinière* bodysuit (see right). But sailors were not so much on the Frenchman's mind as the sea and its creatures. Somewhere along the line, the designer must have gotten hungry, as there was also a dress named for a sushi box. From there he dove into a Japanese theme, as he did for a ready-to-wear outing in Spring/Summer 1999 (see p. 278).

With his diving goggles on, Gaultier referred to his sharp pointed shoulders and criss-cross shapes as 'sharks' and 'fins'. It's not much of a stretch to see a similarity between the pointed ridges of sharks' teeth and the crisp folds of accordion pleats; this outing was titled 'Game of Pleats' after all. Hamish Bowles had previously reported that Gaultier's atelier included *petites mains* who had worked with Madame Grès, but these folds and gathers were not in a (neo-)classical bent. They were used boldly on stiff belts that projected straight out from the waist; dubbed 'îlots' (little islands), they were like the 'sun' shoulder projections from Spring/Summer 2017 (see p. 580), but, applied to the midriff, they gave a pencil sketch of a tutu minus volume.

Some of the most amazing uses of this technique were the most subtle and modern. Look 3 featured a tank with infinite folds in airy organza (see opposite, top left); and Look 7 (see opposite, bottom right), described in the show notes as 'a two-in-one trompe-l'oeil pantsuit… in a single wave of navy blue pleated muslin', was constructed with an easy-to-miss brilliance. Building on the carefree brightness of a day at the beach was a tank/blouson in white and 'breath of fresh air' yellow organza, with pleats as undulant as those of a jellyfish, paired with pants of a jewel-like reddish purple. There were many pieces in the collection with show-off savoir-faire, but looks like these, reinterpreting ready-to-wear silhouettes using couture techniques, were the collection's hidden treasures. Gaultier also resurfaced one of his body prints this season (see p. 599, left): its printed and bedazzled contours were described in the notes as 'body waves of sparkling blue crystals', nicely riding the wave of nostalgia on which the designer surfed, along with his loyal fans.

False Pretences

In the space of six months, Jean Paul Gaultier moved his focus from sea creatures (see p. 596) to wild beasts. The designer, who used both fur and fur-prints throughout his career, favoured the latter in a collection that played with optical illusions. Also back for an encore were the body prints first introduced for the Mad Max show of Autumn/Winter 1995 (see p. 216; opposite, bottom left and p. 602, left). They received different treatments, such as quilting and bejewelling, and were described as being 'hallucinatory, in the spirit of Vasarely'.

There were other nods to ready-to-wear and couture shows past, like the 'prosthetic arm'-type sleeves shown in the 1994 'Tattoos' show (see p. 198; p. 602, right); the webbed armour from Autumn/Winter 2003 couture (see p. 358); and the empire-tall pinstripe suspender pants from the 'Chic Rabbis' era (see p. 190; opposite, right). 'I love the idea of something rising from its ashes, like the phoenix,' the designer told *Vogue*.

Gaultier traded in the X shape (see p. 596) for that of the tented cones that fell over the models' heads like teepees. Certainly not dunces' caps, these might have been thought to bear some relation to the Dadaist Hugo Ball, whose work was referenced by the likes of David Bowie and Klaus Nomi, but no: as *Vogue* reported, Gaultier said 'he'd composed the collection around the idea of hoodies, which he deftly spun out in a medley of conical ways'.

Tempering this drama were looks that iterated on what people were wearing on the street, which had been a stranger to haute couture until Yves Saint Laurent showed a beat-inspired moto for Christian Dior, to much derision. Gaultier picked that thread up early in his career in ready-to-wear and carried it over to couture. It was present in this collection in a rich camel coat with extreme lapels worn with couture cords and a 'hood-cap-balaclava' (see opposite, top left) and a sister-like variation on it, featuring a short grey jacket. With Gaultier having recently debuted his *Fashion Freak Show*, a semi-autobiographical and star-studded cabaret revue of his work and pop culture, looks like these were a reminder that the freaky isn't the only way to be chic-y.

50 Years of Fashion

One week before his Spring/Summer 2020
couture collection, Jean Paul Gaultier, with
his characteristic *je ne regrette rien* attitude
and good humour, announced on social media
that this runway would be his last, though
he assured viewers that the atelier would
continue with a different format. That was
later revealed to be a seasonal cast of
rotating designers creating lineups inspired
by the archives – an idea Gaultier said was
recycled from his time at the house of Patou.

Returning to things, reusing things. What
had been a necessity at the cash-poor start
of the designer's career became a tenet of his
practice, and one aspect of his iconoclasm.
He refused to create newness for the sake
of it, but consistently reiterated, expanded
on, reframed his lifelong obsessions with the
marinière, say, or the corset, *le smoking*, Paris,
punk, pinstripes, cone bras, body armour,
jeans, trompe l'oeil, etc. Though he's not
usually grouped with the deconstructionists,
he always was one. He might have described
his grand finale as his 'first upcycling haute
couture collection', but it was so only in scale;
the designer had been reusing tropes and
existing looks for years.

More than a fashion show, this was
entertainment, with various performers and
star turns on the runway. Boy George, who
was front-row from early days, got top billing.
The show opened, reported Hamish Bowles,
with a fashion-shoot-staged-as-a-funeral
scene from the cult film *Who Are You,
Polly Maggoo?* (p. 607, top right), followed
by 'mourners' assembling in a tableau on the
set, and then a coffin – kitted out with cone
breasts – being carried on to the stage (see
right and p. 606). This was opened to reveal
a model in a white baby doll dress constructed
of miniature versions of itself (see p. 609),
followed by a glove dress (see p. 610, left);
combined, they were a 'communion outfit'
spectacular – one that reinforced the
message on the funeral wreath, which
read 'La Mode Pour La Vie' (Fashion for
Life) (see p. 608). It's a motto that stands in
contrast to the punk one Gaultier had earlier
adopted: 'Too fast to live, too young to die'.
This swansong was testament to the fact
that Gaultier didn't just survive fashion;
he continued to revel in it – contagiously.

La mode pour la vie!

Bibliographic Note

In order not to disrupt the flow of reading, we have decided not to include references or footnotes in the main body of the text. Sources for the quotations in the introductions and collection texts can be found below.

A Robin Abcarian, 'Pyramid styles point to exotic French flair', *Detroit Free Press*, 27 October 1988

Hilary Alexander, 'A triumph for Gaultier's cavalier fashion', *The Daily Telegraph*, 9 July 2004; 'Gaultier's caged birds of paradise', *The Daily Telegraph*, 3 July 2008; 'Ghost of Sleepy Hollow stalks Gaultier catwalk', *The Daily Telegraph*, 1 March 2006; 'Inspired Gaultier creates a fairytale from the steppes', *The Daily Telegraph*, 9 July 2005; 'Jean genie', *The Sunday Telegraph*, 19 January 1997

Associated Press:

(Jenny Barchfield), 'Too haute for recession', *Dothan Eagle* (Alabama), 30 January 2009

(Joelle Diderich), 'Galliano dazzles for Christian Dior', *Toronto Star*, 23 January 2003

(Joelle Diderich), 'Nature fertile inspiration for designers', *The Republic* (Indiana), 9 March 2008

'Paris does prom dress', *Globe-Gazette* (Iowa), 4 October 2009

(Suzy Patterson), 'Audience loves touch of Russia', *Ledger-Enquirer* (Georgia), 13 July 1997

(Suzy Patterson), 'In Paris, curves call the fashion shots', *Tallahassee Democrat*, 27 March 1987

(Suzy Patterson), 'Lagerfeld, Montana tally solid hits in Paris', *The Belleville News-Democrat* (Illinois), 25 October 1985

(Suzy Patterson), 'Montana recycles glamour; Gaultier still wild at heart', *The Daily Herald*, 22 October 1992

(Suzy Patterson), 'Some Like It Haute: Jean Paul Gaultier wowed Paris with East Indian glitz', *The Record* (New Jersey), 20 January 2000

Associated Press/Reuters, 'High season for fall-winter high fashion', *The Montreal Gazette*, 11 July 2000

Mimi Avins, 'Big on Drama', *Los Angeles Times*, 16 March 1998; 'The Blushing Bride Thing Is Over', *Los Angeles Times*, 17 October 1996; 'Welcome Departures', *Los Angeles Times*, 20 March 1997

B Lynn Barber, 'Jean-Paul Gaultier', *Winston-Salem Journal*, 20 January 1999

Jeanne Beker, 'A Riot of Colour', *National Post* (Toronto), 18 March 2003; 'Couture Comeback', *Toronto Star*, 14 July 2011; 'Haute couture gets a fresh look', *The Toronto Star*, 30 January 2012; 'Paris 2001', *The Vancouver Sun*, 17 October 2000

Tim Blanks, 'Jean Paul Gaultier Fall 2011 Couture', Style.com, 5 July 2011; 'Jean Paul Gaultier Spring 2011 Couture', Style.com, 25 January 2011; 'Jean Paul Gaultier Spring 2012 Couture', Style.com, 24 January 2012

Tim Blanks, quoted in Laird Borrelli-Persson, 'What Do Hairdryers and Cyberpunks Have in Common? Jean Paul Gaultier's Fall 1995 Collection and His Camp Sensibility', Vogue Runway, 30 April 2019

Laird Borrelli-Persson, 'In Advance of Jean Paul Gaultier's Final Show, We Present His Couture Debut for 1997', *Vogue* (USA), 17 January 2020; 'Want to Know Why Jean Paul Gaultier's Fall 1995 Collection Is the Best Show Ever? Watch This Video', Vogue.com, 1 April 2020

Hamish Bowles, 'Jean Paul and Me: Hamish Bowles's Gaultier Chronicles', Vogue.com, 24 January 2020; 'Jean Paul Gaultier Fall 2000 Ready-to-Wear', Style.com, 29 February 2000; 'Jean Paul Gaultier Fall 2014 Couture', Style.com, 9 July 2014; 'Jean Paul Gaultier Spring 2014 Couture', Style.com, 22 January 2014; 'Jean Paul Gaultier Spring 2020 Couture', Vogue Runway, 22 January 2020

Sally Brampton, 'Paris Nexus: Sally Brampton talks to Jean Paul Gaultier', *The Observer*, 28 October 1984; 'The wonderful world of Jean Paul Gaultier', *The Guardian*, 28 October 1991

Genevieve Buck, 'Paris fashion collections', *Chicago Tribune*, 23 October 1991; 'Tout Sweet', *Chicago Tribune*, 29 October 1986

Karen Burshtein, 'Leg sleeves and pillow collars', *National Post* (Toronto), 12 March 2005; 'Right To The Jugular', *National Post* (Toronto), 28 January 2006

C Roy H. Campbell, 'Hello? Excitement makers?', *The Philadelphia Enquirer*, 22 October 1995; 'Punk surfaces among designers, with safety pins, pierced parts', *The Philadelphia Inquirer*, 31 October 1993

Jess Cartner-Morley, 'Into the night: Gaultier ditches jokey image', *The Guardian*, 22 January 2001; 'This is the stuff that dreams are made of', *The Guardian*, 14 July 2000

Isabelle Cerboneschi, 'Gaultier, l'histoire sans fin', *Le Temps* (Geneva), 28 September 2014

Regan Charles, 'Paris ready-to-wear is tres jolie', *The News Tribune* (Florida), 4 January 1985

Ann Chubb, 'Accent on Fashion: Green fur for cool cats', *Wales on Sunday*, 26 March 1989

Laura Craik, 'Gaultier looks to India for inspiration', *The Guardian*, 17 January 2000; 'Madonna's a shade late', *Evening Standard* (London), 25 January 2006

D Frank DeCaro, 'Avant-Garde Holds the Cutting Edge', *Newsday* (New York), 14 October 1993; 'Panting for More', *Newsday* (New York), 19 October 1992; 'Redefining Luxy: Old-guard French designers prepare for less ostentatious times', *Newsday*, 23 March 1992; 'The Return of '80s Opulence', *Newsday* (Long Island), 19 March 1996

Joelle Diderich, 'The Reviews: Jean Paul Gaultier', *WWD*, 6 July 2017; 'The rule breakers', *The Hamilton Spectator*, 5 October 2006

Doris Domoszlai-Lantner, 'Fashnost, and Jean Paul Gaultier's Russian Constructivist Collection, 1986', MA dissertation, S.U.N.Y. Fashion Institute of Technology, May 2018

Richard Dorment, 'Couture is today's contemporary art', *The Daily Telegraph*, 24 January 2004

Hebe Dorsey, 'Paris Fashion', *International Herald Tribune*, 23 March 1987

John Duka, 'In Paris, new fashions reflect opposite moods', *The New York Times*, 19 October 1983; 'Paris: Parades of Patriotism', *Times Colonist* (British Columbia), 27 October 1983

E Lesley Ebbetts, 'Just Dandy', *Daily Mirror*, 29 March 1984

Explore France, 'The Secret Celtic Heritage of Brittany', 17 March 2016 (accessed April 2024)

F Fairchild News Syndicate, 'Paris Trends: *Liberation*', *Palm Beach Daily News*, 10 April 1987

Sherly Fitzgerald, 'Gaultier: Big time in the Big Apple', *Newsday*, 27 September 1984

Susannah Frankel, 'No, no, no! Jean Paul Gaultier's tribute to Amy Winehouse hits all the wrong notes', *The Independent*, 26 January 2012; 'Principles, politics and love. There's more to Jean Paul Gaultier than funny bras and Eurotrash', *The Guardian*, 6 June 1997; 'Twist in the tails: Gaultier lights up the Paris catwalk with his traditional flair', *The Independent*, 4 July 2012

Nadine Frey, 'Designers skirt issue of length with a passion', *Chicago Tribune*, 18 March 1991

Vanessa Friedman, 'Armani's Shock to the System', *The New York Times*, 8 July 2015

Alexander Fury, 'Conchita Wurst becomes a "bride" on the Paris catwalk – and proves there is life after Eurovision', *The Independent*, 10 July 2014

G Robin Givhan, 'Black Chic', *The Washington Post*, 1 December 1997; 'Deluge and Drought: The Fickle Muse in Paris', *The Washington Post*, 16 March 2001; 'Fashion rules over chemistry', *Detroit Free Press*, 14 March 1994; 'Flashes of Brilliance in the City of Light', *The Washington Post*, 19 October 1998; 'Galliano jumps to Dior as Paris struts its stuff', *Toronto Star*, 17 October 1996; 'Gaultier's Fantasy Island', *The Washington Post*, 11 October 1999; 'Punk Designers Rediscover Tattoos, Body Adornment, Leather and Metal', *Detroit Free Press*, 17 October 1993

David Graham, 'Now is not the time for fashion to offend', *Toronto Star*, 4 October 2001; 'Photographers boycott Gaultier's show', *Toronto Star*, 10 March 1999; 'Putting it together', *Toronto Star*, 13 March 2003

Michael Gross, 'Gaultier: Fashion Designed to Provoke', *The New York Times*, 31 October 1986

The Guardian, 'Here come the brides! Jean Paul Gaultier's wedding-themed couture show – in pictures', 28 January 2015

H Michelle Hancock, 'Paris fall/winter preview', *Fort Worth Star-Telegram*, 8 April 1987

Holly Hanson, 'Flashy, improbable clothes rule runways', *Centre Daily Times* (Pennsylvania), 23 October 1997; 'Top designers show memorable, wearable clothes in Paris', *Detroit Free Press*, 21 March 1996; 'Variations on a theme', *Detroit Free Press*, 17 March 1998

Nancy Hastings, 'Gaultier pays homage to streetwise wit', *Toronto Star*, 27 October 1987

David Hayes, 'Gaultier's Special Brew goes down well in Paris', *Evening Standard* (London), 12 October 2000

Valli Herman-Cohen, 'Flying Colors', *Los Angeles Times*, 12 March 2002

Julie Hinds, 'Designer courts controversy in his tribute to Judaism', *Gannett News Service*, 24 March 1993

Sara Jane Hoare, 'Spring Chic', *The Observer*, 26 October 1986

Woody Hochswender, 'Fashion in Paris: It's Irrelevant but Who Cares?', *The New York Times*, 21 October 1990

Cathy Horyn, 'Gaultier's Triumph: Crystal Jeans Add Realism to Couture', *The New York Times*, 18 January 2000; 'In Paris, Discipline, Decadence And the Old Order Changes', *The New York Times*, 14 July 2002; 'In Paris, Where the Awards Show Runway Begins' *The New York Times*, 21 January 2003; 'Longer skirts advance down Paris runways', *Daily Hampshire Gazette* (Massachusetts), 25 March 1992; 'Nostalgia Tripping to the Mysterious East and Psychedelia', *The New York Times*, 10 July 2001; 'Rethinking Couture Down to the Skin', *The New York Times*, 13 July 2003

Nina Hyde, 'Jean-Paul Gaultier: Giving New Twists to Old Fashion Notions & Clowning With the Classics', *The Washington Post*, 20 October 1984; 'The '90s Look Sexy, Sleek Suited', *The Washington Post*, 21 March 1989; 'The Cutting Edge', *The Washington Post*, 24 October 1989

I Michelle Ingrassia, 'Americans in Paris', *Newsday* (Long Island), 22 October 1998

Tina Isaac-Goizé, '"It's couture, but it's also reality" – a conversation between Jean Paul Gaultier and his new guest designer Julien Dossena', *Vogue Singapore*, 4 July 2023; 'Jean Paul Gaultier Fall 2019 Couture', Vogue Runway, 4 July 2019

J Robert Janjigian, 'A roll in the hay', *The Hamilton Spectator*, 14 October 2005; 'Amazing, Graceful', *Palm Beach Daily News*, 12 October 2003; 'Spring 2004 collections feature skirts, dresses, tweeds', *Ventura County Star*, 12 October 2003

Tish Jett and Monique, 'Skirts, Suits and Sex Appeal', *Daily News* (New York), 28 March 1982

K Barbra Katz, 'Gaultier talks of the role of men's clothing in a sexy world', *The Montreal Gazette*, 1 April 1986

L Bettijane Levine, 'Paris Fashion, Spring-Summer '87: Serenity prevails in shows and clothes', *Los Angeles Times*, 20 October 1986

Tim Lewis, 'Jean Paul Gaultier: "I love the eccentricity and the freedom of England"', *The Guardian*, 15 May 2022

David Livingstone, 'Fun-loving Gaultier', *The Globe and Mail* (Toronto), 24 February 1987

Véronique Lorelle, 'La mode sans chloroforme', *Le Monde*, 30 January 2009

Thierry-Maxime Loriot (ed.), *The Fashion World of Jean Paul Gaultier: From the Sidewalk to the Catwalk*, Montreal Museum of Fine Arts / Abrams, 2011

Pati Lowell, 'Gaultier's groupies a show within the show', *The Palm Beach Post*, 31 October 1989

Marylou Luther, 'New Fitness Craze: Europe Whittles Away at Waist, Hips', *Los Angeles Times*, 26 November 1982; 'Paris: A season of contradiction and cacophony', *Newsday* (Long Island), 19 October 2000; 'Paris: A World of Design From the French Collection', *Newsday* (Long Island), 18 March 2002; 'Paris: Fall 2003', *Newsday* (Long Island), 17 March 2002; 'The French Blacklash', *Los Angeles Times*, 31 March 1982; 'The Heavenly Look Rises to the Occasion After Atomic Fallout', *Los Angeles Times*, 26 March 1984; '"Third Sex" Comes Out of the Closet', *Los Angeles Times*, 23 October 1984

M Suzy Menkes, 'Fashion: Gaultier and the last samurai', *International Herald Tribune*, 23 January 2004; 'Fashion: Gaultier's wild gallop to the end', *International Herald Tribune*, 9 July 2004; 'Jean Paul Gaultier: A Journey into Space', *The New York Times*, 2 March 2014

Iona Monahan, 'Fans and fashion experts get their fill in 10 days of shows', *The Montreal Gazette*, 1 November 1983; 'Gaultier at his best', *The Montreal Gazette*, 23 March 1999; 'Gaultier goes north', *The Montreal Gazette*, 29 March 1994; 'Irreverent young designers put flair in Paris shows', *The Montreal Gazette*, 22 October 1982; 'New Paris Designs Give Skin No Place to Hide', *The Montreal Star*, 6 November 1976; 'Paris designers go bizarrely Oriental', *The Montreal Gazette*, 21 October 1980; 'Paris Diary', *The Montreal Gazette*, 7 April 1981; 'Ringmaster: Gaultier's circus spoofed the formal shows', *The Montreal Gazette*, 26 March 1991

Booth Moore, 'In Paris, fashion flaunts innovation, nuance', *Los Angeles Times*, 3 March 2007; 'Looking back while charging forward', *Los Angeles Times*, 6 October 2006

Pat Morgan, 'Antifashion elite bored with clothes', *Detroit Free Press,* 29 March 1990

Bernadine Morris, 'Paris fashions a "revolution" every six months', *The Salisbury Post*, 16 April 1978

Sarah Mower, 'Jean Paul Gaultier Fall 2002 Couture', Style.com, 10 July 2002; 'Jean Paul Gaultier Fall 2003 Couture', Style.com, 8 July 2003; 'Jean Paul Gaultier Fall 2003 Ready-to-Wear', Style.com, 7 March 2003; 'Jean Paul Gaultier Fall 2005 Couture', Style.com, 7 July 2005; 'Jean Paul Gaultier Fall 2009 Couture', Style.com, 7 July 2009; 'Jean Paul Gaultier Spring 2003 Couture', Style.com, 19 January 2003; 'Jean Paul Gaultier Spring 2003 Ready-to-Wear', Style.com, 4 October 2002; 'Jean Paul Gaultier Spring 2006 Couture', Style.com, 24 January 2006; 'Jean Paul Gaultier Spring 2009 Couture', Style.com, 27 January 2009; 'Jean Paul Gaultier Spring 2010 Couture', Style.com, 26 January 2010; 'Paris in Style', *The Guardian*, 20 October 1986

O Susan Orlean, 'Fantasyland', *New Yorker*, 19 September 2011

Maureen O'Sulivan, 'Gaultier's racy, lacy designs star in theatrical show', *Palm Beach Daily News*, 20 October 1991

P Anna Pawlowski, *Avec l'ami Jean Paul Gaultier*, Hugo Image, 2021

Gladys Perint Palmer, 'Fashion history repeats: What was good for the Turks is good for Paris fall/winter', *The San Francisco Examiner*, 19 March 1990; 'Shaking up Paris: Jean Paul Gaultier's naughty nuns cause the biggest rumble', *The San Francisco Examiner*, 23 October 1989

Nicole Phelps, 'Jean Paul Gaultier Fall 2008 Ready-to-Wear', Style.com, 25 February 2008; 'Jean Paul Gaultier Fall 2009 Ready-to-Wear', Style.com, 6 March 2009; 'Jean Paul Gaultier Fall 2010 Ready-to-Wear', Style.com, 5 March 2010; 'Jean Paul Gaultier Fall 2012 Ready-to-Wear', Style.com, 2 March 2012; 'Jean Paul Gaultier Fall 2015 Couture', Vogue Runway, 8 July 2015; 'Jean Paul Gaultier Fall 2018 Couture', Vogue Runway, 4 July 2018; 'Jean Paul Gaultier Spring 2009 Ready-to-Wear', Style.com, 29 September 2008; 'Jean Paul Gaultier Spring 2015 Couture', Style.com, 28 January 2015; 'Jean Paul Gaultier Spring 2015 Ready-to-Wear', Style.com, 27 September 2014

Press of Atlantic City, 'Aahhh, Paris in the spring; Designers show individuality in collections', 31 October 1989

Grace Proven, 'French Collection', *Pittsburgh Post-Gazette*, 2 April 1977

R Geraldine Ranson, 'Paris for the Serious Set', *The Sunday Telegraph*, 30 March 1986

Reuters News Service (Joelle Diderich), 'Galliano dazzles for Christian Dior', *Toronto Star*, 23 January 2003

Margaret Roach, 'Only the French', *Newsday* (Long Island), 19 October 1985; 'Paris: Celebrating the Body Beautiful', *Newsday* (Long Island), 27 October 1985

Mary Rourke, 'A Global Outlook: Fashion: Japanese designers make a splash in Paris. But it's the French who impress with an Eastern Europe influence', *Los Angeles Times*, 19 March 1990; 'Designers strut their stuff, but customers wear jeans', *The Modesto Bee* (California), 16 October 1992

Judy Rumbold, 'Special Deliveries', *The Sydney Morning Herald*, 27 October 1988

Susie Rushton, 'Gaultier opts for a mish-mash from the Mediterranean', *The Independent*, 26 January 2006; 'Pump up the volume', *The Independent*, 29 January 2004

S Kathryn Samuel, 'Bad News from Sinister City', *Leicester Mercury* (UK), 17 April 1979; 'Confusion Reigns', *The Daily Telegraph*, 24 October 1988

Liana Satenstein, 'The A-Z Guide to Jean Paul Gaultier', ssense.com (accessed 7 March 2025)

Liz Smith, 'Post-punk in Paris', *Evening Standard* (London), 15 October 1979

Mimi Spencer, 'Allo matelot: the charm', *Evening Standard* (London), 12 March 1998; 'Now high fashion meets hip in Gaultier', *Evening Standard* (London), 23 January 1998

Amy M. Spindler, 'Among Couture Debuts, Galliano's Is the Standout', *The New York Times*, 21 January 1997; 'Gaultier enjoys going to extremes', *The Hamilton Spectator* (Ontario), 23 October 1997; 'Gaultier pays cultural homage with respect', *Austin American-Statesman*, 27 March 1997; 'In Paris Couture, the Spectacle's the Thing', *The New York Times*, 21 July 1998; 'Patterns: Piercing Picks Up', *The New York Times*, 19 October 1993; 'Treating History With a Sense of Pride', *The New York Times*, 17 March 1997

Stephanie Sporn, 'Jean Paul Gaultier Considered Cinema His "Fashion Design School"', *Vogue*, 4 May 2024

Style.com, 'Jean Paul Gaultier Spring 2001 Couture', 20 January 2001; 'Jean Paul Gaultier Spring 2002 Ready-to-Wear', 9 October 2001

T Jessica Testa, 'Gaultier's "Children" Are Happy for Him', The New York Times, 23 January 2020

Dennis Thim, 'Paris Sizzles', *WWD*, 15 October 1987

Stephen Todd, 'Jean Paul Gaultier Spring 2002 Couture', Style.com, 19 January 2002

Eugénie Trochu, trans. Charlotte Sutherland-Hawes, 'Jean Paul Gaultier's 20 favorite films', *Vogue* (France), 7 February 2021

Priscilla Tucker and Monique, 'French Triangles', *Daily News* (New York), 7 April 1979

Lowri Turner, 'Pierce de resistance', *Evening Standard* (London), 11 October 1993

V Alison Veness, 'Cowgirls get the neoprene', *Evening Standard* (London), 19 October 1995

W Celia Walden, 'Jean-Paul Gaultier Interview', *The Telegraph*, 8 December 2010

Lyla Blake Ward, '1952: The First Time I Saw Paris', francerevisited.com, 13 September 2021 (accessed 7 March 2025)

Constance C. R. White, 'Couture takes fashion lead again', *The Miami Herald*, 28 January 1998; 'The Bad Boy of Paris Who Made Good', *The New York Times*, 19 January 1999

Wire Reports, 'Spring '92 Preview: Paris', *Fort Worth Star-Telegram*, 31 October 1991

Wire Services, 'Fashion world loves Paris when it sizzles', *The Indianapolis Star*, 27 October 1985

WWD, 'French Maids, Marionette Models, and Marie Antoinette', 5 March 2004; 'Gaultier: The Court Jester of Paris', 18 April 1984; 'Jean Paul Gaultier RTW Spring 2012', 2 October 2011; 'Paris signals: Sexy shapes, bright colors', 19 October 1981; 'Paris: It's too darn hot', 22 October 1984; 'Paris Now', 21 March 1988; 'Paris this weekend: Tidbits, no feast', 25 March 1985; 'Young looks spark paris', 31 March 1980; 'Puttin' On the Glitz', 19 July 1999

Collection Credits

S/S 1977 Ready-to-Wear
21 October 1976; Planétarium
du Palais de la Découverte,
Paris

A/W 1977–1978 Ready-to-Wear
La Cour des Miracles, Paris

S/S 1978 Ready-to-Wear
Théâtre des Champs-Élysées,
Paris

A/W 1978–1979 Ready-to-Wear
Salle Wagram, Paris

S/S 1979 Ready-to-Wear
Salle Wagram, Paris
Hair: Romain for Patrick Alès
Makeup: Linda Mason
for Helena Rubinstein
Shoes and gloves (stylist):
Melka Tréanton

A/W 1979–1980 Ready-to-Wear
6 April 1979; L'Hôtel
Intercontinental, Paris

S/S 1980 Ready-to-Wear
12 October 1979; Salle Wagram,
Paris

A/W 1980–1981 Ready-to-Wear
Salle Wagram, Paris

S/S 1981 Ready-to-Wear
17 October 1980; Salle Wagram,
Paris

A/W 1981–1982 Ready-to-Wear
28 March 1981; Salle Wagram,
Paris

S/S 1982 Ready-to-Wear
Salle Wagram, Paris

A/W 1982–1983 Ready-to-Wear
Salle Wagram, Paris

S/S 1983 Ready-to-Wear
15 October 1982; Palais
du Louvre, Paris

A/W 1983–1984 Ready-to-Wear
Gaultier's studio, Right Bank

S/S 1984 Ready-to-Wear
Tents at the Carreau du Louvre,
Paris

A/W 1984–1985 Ready-to-Wear
23 March 1984; Cirque d'Hiver,
Paris

S/S 1985 Ready-to-Wear
19 October 1984; Cirque
d'Hiver, Paris

A/W 1985–1986 Ready-to-Wear
Cirque d'Hiver, Paris

S/S 1986 Ready-to-Wear
18 October 1985; Pavillon
Baltard, Nogent-sur-Marne

A/W 1986–1987 Ready-to-Wear
21 March 1986; Grande Halle
de La Villette, Paris

S/S 1987 Ready-to-Wear
17 October 1986; Grande Halle
de La Villette, Paris

A/W 1987–1988 Ready-to-Wear
Grande Halle de La Villette, Paris

S/S 1988 Ready-to-Wear
16 October 1987; Grande Halle
de La Villette, Paris

A/W 1988–1989 Ready-to-Wear
18 March 1988; Grande Halle
de La Villette, Paris

S/S 1989 Ready-to-Wear
21 October 1988; Grande Halle
de La Villette, Paris

A/W 1989–1990 Ready-to-Wear
17 March 1989; Grande Halle
de La Villette, Paris
Makeup: Stéphane Marais

S/S 1990 Ready-to-Wear
Grande Halle de La Villette,
Paris

A/W 1990–1991 Ready-to-Wear
16 March 1990; Espace Elysée,
Paris
Hair: Julien d'Ys and Yannick D'Is
Makeup: Stéphane Marais

S/S 1991 Ready-to-Wear
19 October 1990; Espace Elysée,
Paris

A/W 1991–1992 Ready-to-Wear
15 March 1991; Cirque d'Hiver
Bouglione, Paris
Makeup: Stéphane Marais

S/S 1992 Ready-to-Wear
18 October 1991; Jardins
Réservés des Tuileries, Paris

A/W 1992–1993 Ready-to-Wear
20 March 1992; Salle Japy,
Paris

S/S 1993 Ready-to-Wear
16 October 1992, Cirque d'Hiver
Bouglione, Paris

amfAR benefit
September 1992; Shrine
Auditorium, Los Angeles, US

A/W 1993–1994 Ready-to-Wear
14 March 1993; Galerie Vivienne,
Paris

S/S 1994 Ready-to-Wear
10 October 1992; Galerie
Vivienne, Paris

A/W 1994–1995 Ready-to-Wear
6 March 1994; 38 Avenue Reille,
Paris

S/S 1995 Ready-to-Wear
14 October 1994; Musée des
Arts Forains, Paris

A/W 1995–1996 Ready-to-Wear
17 March 1995; Le Trianon, Paris
Makeup: Topolino

S/S 1996 Ready-to-Wear
17 October 1995; Carreau
du Temple, Paris

A/W 1996–1997 Ready-to-Wear
15 March 1996; Halle Pajol,
Paris

S/S 1997 Ready-to-Wear
11 October 1996; l'Elysée
Montmartre, Paris

S/S 1997 Haute Couture
15 January 1997; 108 rue Vieille
du Temple, Paris

A/W 1997–1998 Ready-to-Wear
14 March 1997; Salle Wagram,
Paris

A/W 1997–1998 Haute Couture
July 1997; La Conciergerie,
Paris

S/S 1998 Ready-to-Wear
17 October 1997; Musée
national des Arts d'Afrique
et d'Océanie, Paris

S/S 1998 Haute Couture
21 January 1998; 15 rue de
l'Ecole de Médecine, Paris

A/W 1998–1999 Ready-to-Wear
13 March 1998; Salle Wagram,
Paris

A/W 1998–1999 Haute Couture
19 July 1998

S/S 1999 Ready-to-Wear
Salle Wagram, Paris

S/S 1999 Haute Couture
17 January 1999; Italian
Consulate, Paris

A/W 1999–2000 Ready-to-Wear
12 March 1999; Musée des Arts
Décoratifs, Paris

A/W 1999–2000 Haute Couture
18 July 1999

S/S 2000 Ready-to-Wear
8 October 1999; Musée des
Arts d'Afrique et d'Océanie,
Paris

S/S 2000 Haute Couture
16 January 2000; Maison
de Noailles, Paris

A/W 2000–2001 Ready-to-Wear
29 February; Salle Wagram,
Paris

A/W 2000–2001 Haute Couture
9 July 2000; Maison
de Noailles, Paris

S/S 2001 Ready-to-Wear
11 October 2000; Carrousel
du Louvre, Paris

S/S 2001 Haute Couture
January 2001; Carrousel
du Louvre, Paris
Hair: Odile Gilbert

A/W 2001–2002 Ready-to-Wear
March 2001; Carrousel du
Louvre, Paris

A/W 2001–2002 Haute Couture
8 July 2001; Maison de
Noailles, Paris

S/S 2002 Ready-to-Wear
9 October 2001; Carrousel du
Louvre, Paris

S/S 2002 Haute Couture
19 January 2002; JPG HQ, 325
rue Saint Martin, Paris

A/W 2002–2003 Ready-to-Wear
9 March 2002; Carrousel du
Louvre, Salle Le Nôtre, Paris

A/W 2002–2003 Haute Couture
11 July 2002; JPG HQ,
325 rue Saint Martin, Paris

S/S 2003 Ready-to-Wear
5 October 2002; Carrousel du
Louvre, Salle Le Nôtre, Paris

A/W 2003–2004 Ready-to-Wear
8 March 2003; Carrousel du
Louvre, Paris

A/W 2003–2004 Haute Couture
9 July 2003; École des
Beaux-Arts, Paris

S/S 2004 Ready-to-Wear
24 September 2003; Carrousel
du Louvre, Salle Le Nôtre, Paris

S/S 2004 Haute Couture
20 January 2004; Palais de
la Porte Dorée, Paris

A/W 2004–2005 Ready-to-Wear
3 March 2004; Carreau du
Temple, Paris

A/W 2004–2005 Haute Couture
8 July 2004; JPG HQ,
325 rue Saint Martin, Paris

S/S 2005 Ready-to-Wear
6 October 2004; JPG HQ,
325 rue Saint Martin, Paris

S/S 2005 Haute Couture
27 January 2005; JPG HQ,
325 rue Saint Martin, Paris

A/W 2005–2006 Ready-to-Wear
28 February 2005; JPG HQ,
325 rue Saint Martin, Paris

A/W 2005–2006 Haute Couture
8 July 2005; JPG HQ,
325 rue Saint Martin, Paris

S/S 2006 Ready-to-Wear
4 October 2005, JPG HQ,
325 rue Saint Martin, Paris

S/S 2006 Haute Couture
25 January 2006; JPG HQ,
325 rue Saint Martin, Paris

A/W 2006–2007 Ready-to-Wear
28 February 2006; JPG HQ,
325 rue Saint Martin, Paris
Hair: Guido Palau
Makeup: Diane Kendal

S/S 2007 Ready-to-Wear
3 October 2006; JPG HQ,
325 rue Saint Martin, Paris

S/S 2007 Haute Couture
24 January 2007; JPG HQ,
325 rue Saint Martin, Paris

A/W 2007–2008 Ready-to-Wear
26 February 2007; JPG HQ,
325 rue Saint Martin, Paris

A/W 2007–2008 Haute Couture
4 July 2007; JPG HQ,
325 rue Saint Martin, Paris
Hair: Odile Gilbert
Makeup: Tom Pecheux

S/S 2008 Ready-to-Wear
2 October 2007; JPG HQ,
325 rue Saint Martin, Paris

S/S 2008 Haute Couture
23 January 2008; JPG HQ,
325 rue Saint Martin, Paris
Hair: Odile Gilbert
Makeup: Tom Pecheux

A/W 2008–2009 Ready-to-Wear
25 February 2008; JPG HQ,
325 rue Saint Martin, Paris
Hair: Guido Palau
Makeup: Diane Kendal
Music: Thierry Planelle
Perfumes: Jean Paul Gaultier
Furs: Saga
Stockings: Wolford and Falke

A/W 2008–2009 Haute Couture
1 July 2008; JPG HQ,
325 rue Saint Martin, Paris
Hair: Odile Gilbert
Makeup: Tom Pecheux

S/S 2009 Ready-to-Wear
29 September 2008; JPG HQ,
325 rue Saint Martin, Paris
Hair: Guido Palau
Makeup: Diane Kendal

S/S 2009 Haute Couture
28 January 2009; JPG HQ,
325 rue Saint Martin, Paris
Hair: Odile Gilbert

A/W 2009–2010 Ready-to-Wear
7 March 2009; JPG HQ,
325 rue Saint Martin, Paris
Makeup: Diane Kendal

A/W 2009–2010 Haute Couture
8 July 2009; JPG HQ,
325 rue Saint Martin, Paris
Hair: Odile Gilbert
Makeup: Tom Pecheux

S/S 2010 Ready-to-Wear
3 October 2009; JPG HQ,
325 rue Saint Martin, Paris
Hair: Guido Palau
Makeup: Diane Kendal

S/S 2010 Haute Couture
27 January 2010; JPG HQ,
325 rue Saint Martin, Paris

A/W 2010–2011 Ready-to-Wear
6 March 2010; JPG HQ,
325 rue Saint Martin, Paris
Makeup: Tom Pecheux

A/W 2010–2011 Haute Couture
14 July 2010; JPG HQ,
325 rue Saint Martin, Paris
Hair: Odile Gilbert
Makeup: Tom Pecheux

S/S 2011 Ready-to-Wear
2 October 2010; JPG HQ,
325 rue Saint Martin, Paris
Hair: Guido Palau
Makeup: Stéphane Marais

S/S 2011 Haute Couture
26 January 2011; JPG HQ,
325 rue Saint Martin, Paris

A/W 2011–2012 Ready-to-Wear
5 March 2011; JPG HQ,
325 rue Saint Martin, Paris

A/W 2011–2012 Haute Couture
6 July 2011; JPG HQ,
325 rue Saint Martin, Paris

S/S 2012 Ready-to-Wear
1 October 2011; JPG HQ,
325 rue Saint Martin, Paris

S/S 2012 Haute Couture
25 January 2012; JPG HQ,
325 rue Saint Martin, Paris

A/W 2012–2013 Ready-to-Wear
3 March 2012; JPG HQ,
325 rue Saint Martin, Paris

A/W 2012–2013 Haute Couture
4 July 2012; JPG HQ,
325 rue Saint Martin, Paris

S/S 2013 Ready-to-Wear
29 September 2012; JPG HQ,
325 rue Saint Martin, Paris

S/S 2013 Haute Couture
23 January 2013; JPG HQ,
325 rue Saint Martin, Paris

A/W 2013–2014 Ready-to-Wear
1 March 2013; Salle Wagram,
Paris

A/W 2013–2014 Haute Couture
3 July 2013; JPG HQ,
325 rue Saint Martin, Paris

S/S 2014 Ready-to-Wear
September 2013; Le Paradis
Latin cabaret bar, St Germain,
Paris

S/S 2014 Haute Couture
22 January 2014; JPG HQ,
325 rue Saint Martin, Paris

A/W 2014–2015 Ready-to-Wear
1 March 2014; Espace Niemeyer,
2 Place du Colonel Fabien, Paris

A/W 2014–2015 Haute Couture
9 July 2014; JPG HQ,
325 rue Saint Martin, Paris
Hair: Odile Gilbert
Makeup: Stephane Marais

S/S 2015 Ready-to-Wear
27 September 2014;
Le Grand Rex, Paris
Hair: Odile Gilbert
Makeup: Stéphane Marais

S/S 2015 Haute Couture
 28 January 2015; JPG HQ,
 325 rue Saint Martin, Paris
 Hair: Odile Gilbert
 Makeup: Stéphane Marais

A/W 2015–2016 Haute Couture
 16 July 2015; JPG HQ,
 325 rue Saint Martin, Paris

S/S 2016 Haute Couture
 27 January 2016; JPG HQ,
 325 rue Saint Martin, Paris

A/W 2016–2017 Haute Couture
 6 July 2016; JPG HQ,
 325 rue Saint Martin, Paris
 Hair: Odile Gilbert
 Makeup: Sam Bryant for
 MAC Pro
 Music: Mode-F
 Manicure: Majeure Prod

S/S 2017 Haute Couture
 25 January 2017; JPG HQ,
 325 rue Saint Martin, Paris
 Hair: Odile Gilbert
 Makeup: Terry Barber

A/W 2017–2018 Haute Couture
 5 July 2017; JPG HQ,
 325 rue Saint Martin, Paris
 Hair: Odile Gilbert
 Makeup: Stéphane Marais

S/S 2018 Haute Couture
 23 January 2018, JPG HQ,
 325 rue Saint Martin, Paris
 Hair: Odile Gilbert
 Makeup: Stéphane Marais

A/W 2018–2019 Haute Couture
 4 July 2018; JPG HQ,
 325 rue Saint Martin, Paris
 Hair: Odile Gilbert
 Makeup: Stéphane Marais

S/S 2019 Haute Couture
 23 January 2019; JPG HQ,
 325 rue Saint Martin, Paris
 Hair: Odile Gilbert

A/W 2019–2020 Haute Couture
 23 January 2018, JPG HQ,
 325 rue Saint Martin, Paris
 Hair: Odile Gilbert
 Makeup: Erin Parsons
 Manicure: Marian Newman

S/S 2020 Haute Couture
 22 January 2020;
 Théâtre du Châtelet, Paris
 Hair: Odile Gilbert
 Makeup: Erin Parsons

Picture Credits

The page numbers below refer to illustrations.

l = left; r = right; a = above; b = below

All images © firstVIEW / Launchmetrics Spotlight unless otherwise indicated

Peter Lindbergh. Courtesy Peter Lindbergh Foundation, Paris: 23

ASU FIDM Museum Collection. Gift of Arnaud Associates. Photograph by Michel Arnaud: 38b, 39a, 40, 41ar, 41b, 42l, 42r, 43br, 59br, 66, 67ar, 67bl, 68–69, 70r, 71l, 73br, 74l, ar, 75, 76al, 76r, 78, 79r, 80al, 80r, 81r, bl, 82, 83l, 83br, 84, 85l, 86al, 87l, 87br, 89, 91a, 92al, 92r, 93l, 94, 95al, 96–97, 98l, 99, 102–103, 104r, 105al, 105r, 106al, 106r, 107al, 108–111, 112ar, 113l, 113ar, 129ar, 132, 133r, 133bl, 134l, 134br, 136l, 138, 140bl, 141al, 142, 143l, 143ar, 145ar, 145bl, 146r, 146bl, 149al, 161bl, 162, 165br, 171l, 174l, 176, 177bl, 177ar, 178b, 181ar, 185br, 190–191, 193, 194r, 195r, 195bl, 196, 197br, 200, 201r, 201r, 201bl

Guy Marineau & Etienne Tordoir / Catwalkpictures: 79l, 81al, 87ar, 92bl, 98r, 100r, 100bl, 104al, 105bl, 106bl, 118–119, 120bl, 120r, 121r, 122bl, 124–125, 126l, 127al, 128, 130, 131r, 131bl, 133al, 135, 136r, 137l, 137br, 139b, 145al, 145br, 146al, 147–148, 149r, 154b, 157ar, 161ar, 163, 167ar, 168–169, 173, 182, 183l, 184, 185l, 192, 201l, 203ar, 208r, 219al, 221a, 226r, 229br, 231ar, 233l, 233br, 245l, 245ar, 258r, 279ar, 283ar, 294, 295r, 297br

Getty Images: AFP 27bl; Stephane Cardinale – Corbis 2, 613a; Stephane Cardinale / Sygma 215a; Dominique Charriau / Wireimage 609, 614–615; Fairchild Archive / Penske Media 43l, 43ar, 45ar, 49al, 51ar, 53ar, 54bl, 255, 259; Ron Galella, Ltd / Ron Galella Collection 188al; Pierre Guillaud / AFP 34–35, 151br; Tim Jenkins / WWD / Penske Media 41a; Guy Marineau / Penske Media 93ar, 101r; Michel Maurou / WWD / Penske Media 45al, 47bl, 47r, 43, 49ar, 49b, 50, 51al, 52, 53l, 53br; 54al, 54r, 55, 56, 57r, 57bl, 58ar, 59l, 90, 91b, 95bl, 185ar; Pool Pat / Arnal / Gamma-Rapho 249r; Pool Simon / Stevens / Gamma-Rapho 213bl; Bertrand Rindoff Petroff 179br; Pascal Le Segretain 607ar; Daniel Simon / Gamma-Rapho 76bl, 93br, 107br, 114, 181bl, 261r, 310, 312al; Jim Smeal / Ron Galella Collection 187b; Frank Trapper / Corbis 188a, 189; Pierre Vauthey / Sygma 131al, 312 bl, 215b, 219bl, 312bl; Victor Virgile / Gamma-Rapho 177al, 177br, 179l, 181l, 183r, 604–605; WWD / Penske Media: 30; Vinnie Zuffante 187a

Courtesy Jean Paul Gaultier: 26, 27tl, 27tr, 27br, 28–29, 36–37, 38a, 39b, 44, 46, 47al, 51b, 57al, 58l, 58br, 59ar, 67al, 73bl, 74br, 77ar, 85br, 86r, 95r, 100al, 104bl, 107ar, 117r, 120al, 121l, 122al, 122r, 123, 126r, 127r, 129br, 156, 157al, 157b, 158–159, 160al, 161a, 161br, 165al, 167al, 170l, 170br, 177al, 178ar, 179ar, 198, 199r, 202l, 202ar, 203al, 204, 205l, 217al, 218al, 220r, 220bl, 238br, 244al

Niall McInerney / Bloomsbury / Launchmetrics / Spotlight: 61ar, 65l, 70l, 77br, 101l, 112l, br, 113br, 116br, 129l, 139al, 150, 151bl, 152al, 152r, 153bl, 175al, 180, 205r, 209br

© Paul van Riel: 31, 32, 33r, 60, 61al, 61b, 62–64, 65r, 71r, 72, 73a, 77al, 80bl, 83ar, 85ar, 86bl, 115, 116l, 116ar, 117l

Shutterstock: Dave Lewis 188ar; Clive Limpkin / ANL 45ar, 45bl; Neville Marriner / ANL 199l, 207l; Ken Towner / ANL 203br

Anthea Simms: 137ar, 141bl, 141r, 143br, 144, 151a, 152bl, 153bl, 160r, 160bl, 164, 165ar, 166, 167b, 170ar, 171r, 175br, 197l, 199al, 202br, 207ar, 208l, 210r, 212, 213al, 213br, 214l, 216, 217ar, 218r, 219ar, 222, 223al, 223r, 224al, 227ar, 227l, 245, 253ar, 267bl, 274r

© Patrice Stable: 139ar, 140al, 140r, 153al, 153r, 154a, 155r, 172, 174r, 206, 207br, 209l, 209ar, 210l, 211, 213ar, 214r, 284, 285a, 285bl, 287al

Every effort has been made to contact all copyright holders. The publishers will be happy to make good in future editions any errors or omissions brought to their attention.

Acknowledgments

The author and the publisher wish to thank Jean Paul Gaultier and his team, and special thanks to Jelka Music, for their expertise and support in the making of this book.

The team at Jean Paul Gaultier would like to thank Antoine Gagey, Bruno Biagi, Capucine Veltz, Clara Vergez, Claire Vital, Daniel Menendez Suarez, Emilien Boland, Jean Paul Gaultier, Jelka Music, Laura Delperre, Lili Pottier, Louana Aladjem, Maria Eugenia Perez, Maryam Moussavi and Shana Barrière.

Index of Models

Index

Cover bellyband (from left to right): Barbès collection,
Fall/Winter 1984–1985 Ready-to-Wear © firstVIEW /
Launchmetrics Spotlight; The Amazons collection,
Autumn/Winter 1995–1996 Ready-to-Wear
Anthea Simms; Tattoos collection, Spring/Summer 1994
Ready-to-Wear Courtesy Jean Paul Gaultier;
Tribute to Frida Kahlo collection, Spring/Summer 1998
Ready-to-Wear © firstVIEW / Launchmetrics Spotlight

Frontispiece (p. 2): Jean Paul Gaultier's final collection,
Spring/Summer 2020 Haute Couture

First published in the U.S. and Canada in 2025 by
Yale University Press
P.O. Box 209040
302 Temple Street
New Haven, CT 06520-9040
yalebooks.com

Published by arrangement with Thames & Hudson Ltd,
London

Jean Paul Gaultier Catwalk: The Complete Collections
© 2025 Thames & Hudson Ltd, London

Text © Laird Borrelli-Persson 2025
Text for Robin Hood and Ska Poets © Thames & Hudson 2025

Photographs © 2025 firstVIEW / Launchmetrics Spotlight
unless otherwise stated

Series concept by Adélia Sabatini
© 2025 Thames & Hudson Ltd, London

Design by Fraser Muggeridge studio

ISBN 978-0-300-28519-2

Library of Congress Control Number: 2025934431

10 9 8 7 6 5 4 3 2 1

Printed and bound in China by C&C Offset Printing Co. Ltd